CLASSIC TECHNIQUES
for Watercolour Landscapes

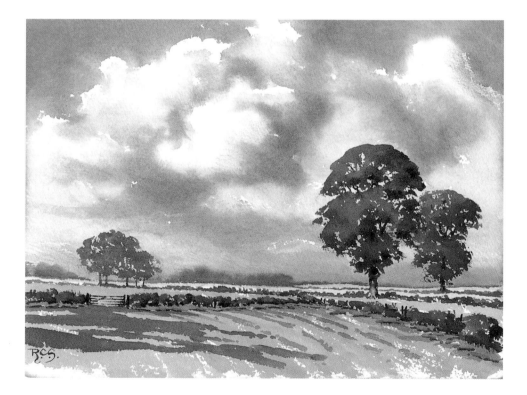

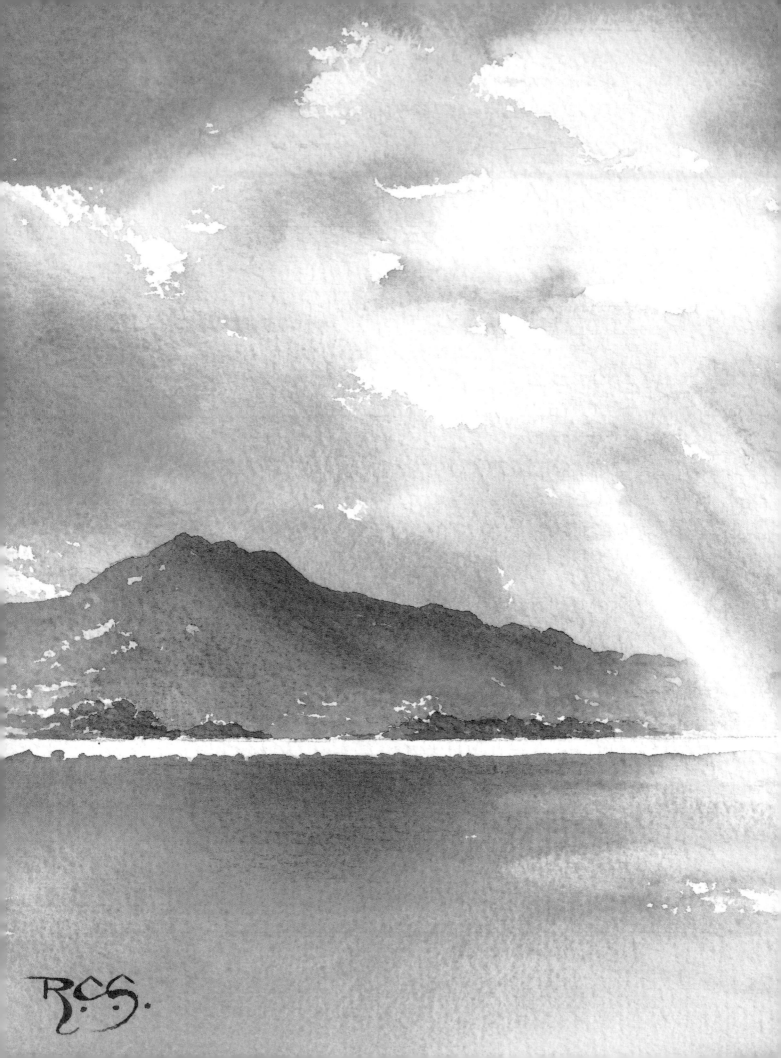

CLASSIC TECHNIQUES
for Watercolour Landscapes

RAY CAMPBELL SMITH

David & Charles

Dedication
To my family, my friends and all those who share my love of pure watercolour.

A DAVID & CHARLES BOOK

First published in the UK in 2002

Copyright © Ray Campbell Smith 2002

Ray Campbell Smith has asserted his right to be
identified as author of this work in accordance with
the Copyright, Designs and Patents Act, 1988.

A catalogue record for this book is available from the
British Library.

ISBN 0 7153 1211 1

Printed in China by Hong Kong Graphics and Printing Ltd.
for David & Charles
Brunel House Newton Abbot Devon

Commissioning Editor Sarah Hoggett
Art Editor Diana Dummett
Senior Desk Editor Freya Dangerfield
Production Roger Lane

Contents

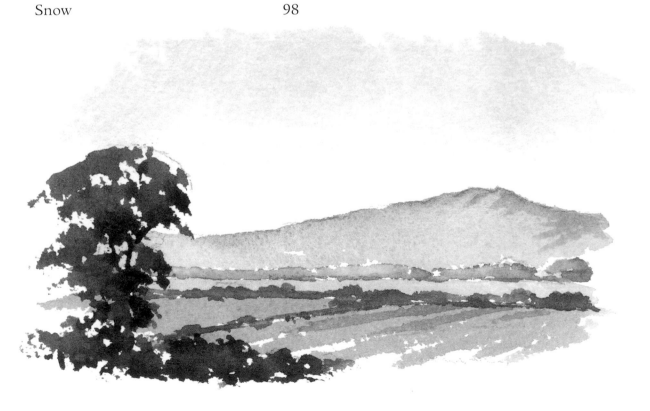

Introduction

Dedicated watercolourists have no doubt that their chosen medium reigns supreme and, when used with imagination and skill, can produce clear and spontaneous effects impossible with any other medium. Fresh, transparent washes which allow the paper to shine through have a unique beauty, and it is these elusive qualities of freshness and transparency that you should always strive to preserve. Once they have been lost, the watercolour medium has little to commend it and you are left with dull, tired and overworked results.

If things go wrong with oils or acrylics, you can happily overpaint, confident in the knowledge that no irreparable harm has been done and that a bold, fresh painting is still possible. With the transparent medium of watercolour there is no second chance, and it is this that gives the medium its reputation for difficulty and can lead many painters to give up the struggle. This book aims to tackle the problem head-on and demonstrate how, with correct

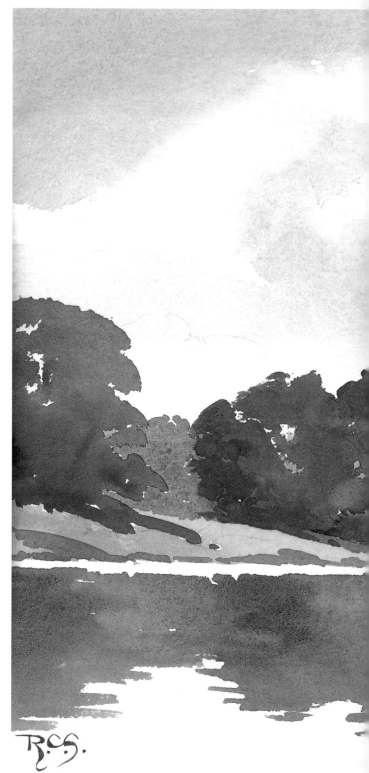

RIVER SCENE

The warm colours in the foreground are set off by the cooler colours and aerial recession in the background, while the reflections of the trees in the water draw the eye to the far bank and buildings.

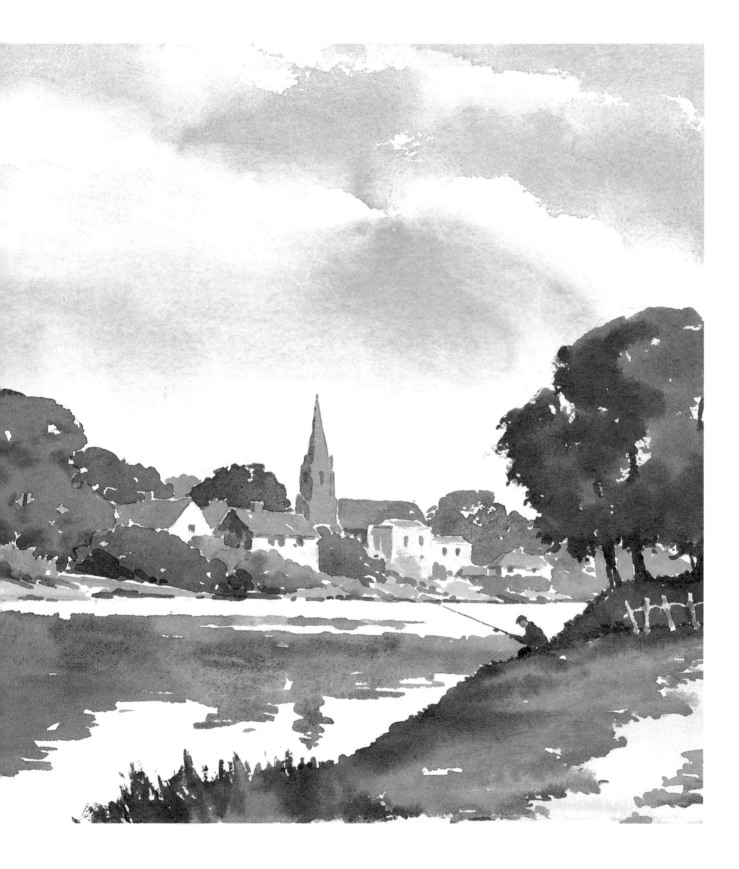

technique, almost anyone can produce watercolours that embody all that is best in the medium. The word 'technique' in this context simply refers to ways of applying pigment correctly – and such techniques can be taught and learnt.

After many years of teaching art, I know the difficulties and pitfalls and, more importantly, how to circumvent them. However, before getting down to watercolour techniques, a word of warning! However loose and free your style, watercolour still demands careful thought and planning before you even think of putting brush to paper. The loose paintings of such watercolour masters as Edward Wesson often look as though they were skilfully dashed off in a matter of minutes, and it is easy to forget the concentrated thought and planning that invariably preceded their rapid execution. It is the scrimping, or even the omission altogether, of the essential planning stage that most frequently leads to disaster.

The inevitable alterations that result from lack of planning are death to fresh, transparent washes, and muddiness then rears its ugly head. So give yourself time to absorb your chosen subject, let it wash over you, and then plan how best you can emphasize those qualities that made you

want to paint the scene in the first place.

Always bear in mind, too, that your painting should not be just a reasonably accurate portrayal of the scene before

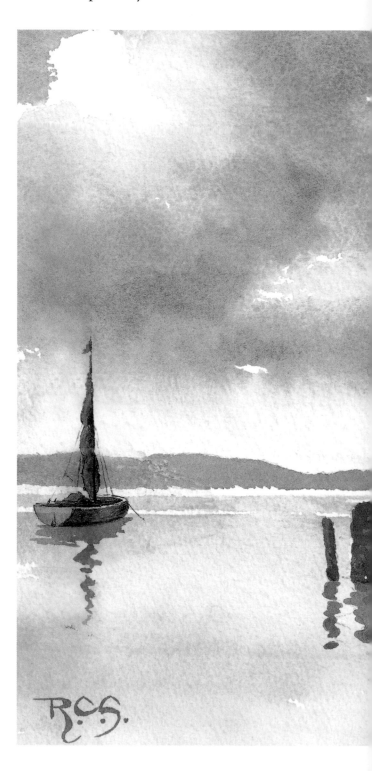

you, but should proclaim, loud and clear, your emotional reaction to it. This may well involve strengthening some aspects and playing down

CORNISH ESTUARY
The indented outlines of the reflections suggest the rippling surface of the water. Care was taken over the drawing of the foreground boats.

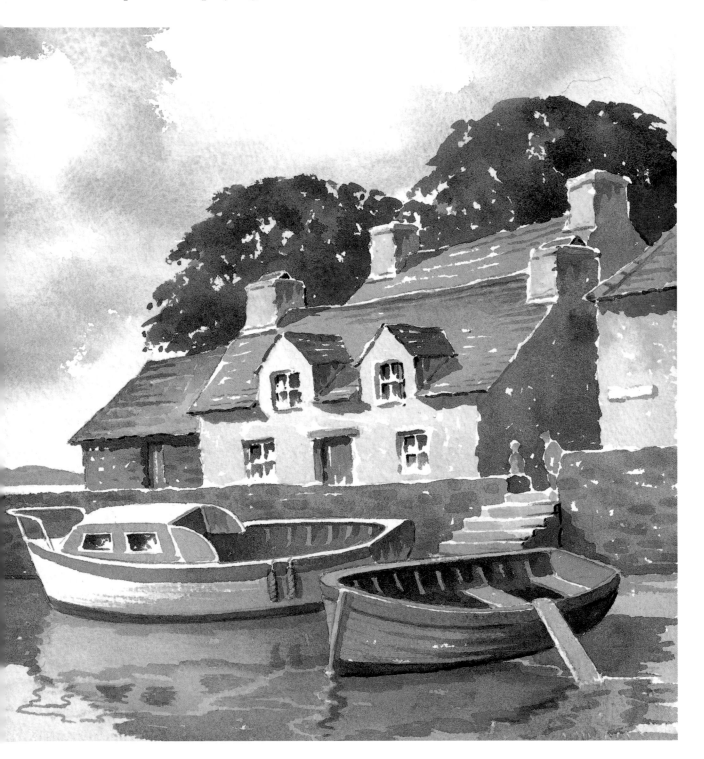

others, rearranging and varying some elements of the subject, omitting irrelevant detail and emphasizing colour and tonal contrasts to increase visual impact. Only then will your painting become more than a run-of-the-mill pictorial record.

At all costs avoid experimenting on your precious watercolour paper. By this I mean laying down a wash to represent some passage in your subject, only to find it wrong in colour or tone or both, and needing alteration. So if you are uncertain of the correctness of your prepared wash, always try it out on a piece of scrap paper first and adjust it if necessary, so that when you use it in your painting, you know it is right and does not need altering. Only in this way can your washes be as fresh and transparent as you would wish. This step is particularly important for inexperienced painters, who are often caught out by the medium's habit of fading markedly on

drying. As I have so often warned my students, 'If it looks right when it's wet, it's wrong!'

Another problem arises when tackling a passage containing a great deal of detail, for example a stretch of shingly foreshore. If you attempt to paint painstakingly every individual pebble, overworking and tiredness will certainly creep in. What you have to do is to employ or adapt some watercolour technique, such as the broken wash, which conveys or suggests the effect you want in a far more painterly and economical way. If the technique does not produce a precise image, it will, however, be a fresh and bold approximation, and this is far more effective than a more careful and exact approach.

In truth, every part of a subject can be effectively handled by using one or more of the basic watercolour techniques, and an essential part of the planning process should be what I can best describe as the mental translation of each passage of the subject into a form that the medium can cope with effectively. This may sound like an oversimplification of a complex process, but as you work through this book you will learn all about the various watercolour techniques and then how to apply them, boldly and freshly, to obtain the effects you desire.

How to use this book

Understanding and choosing the right materials is the first step to improving your painting technique, and Part 1 deals with this in detail before moving on to the all-important subject of watercolour technique. Then in Part 2, there are seven sections that demonstrate how every feature of the landscape can be effectively and economically captured through the application of one or more of these techniques: skies, light, foregrounds and backgrounds, trees and foliage, buildings of all kinds, water and snow scenes. The final section, Part 3, shows how preliminary field sketches can be developed into finished paintings through the application of the techniques you have studied.

EVENING RIDE
Only the nearer wave forms have been dealt with in any detail – the more distant are indicated by broken lines of white paper.

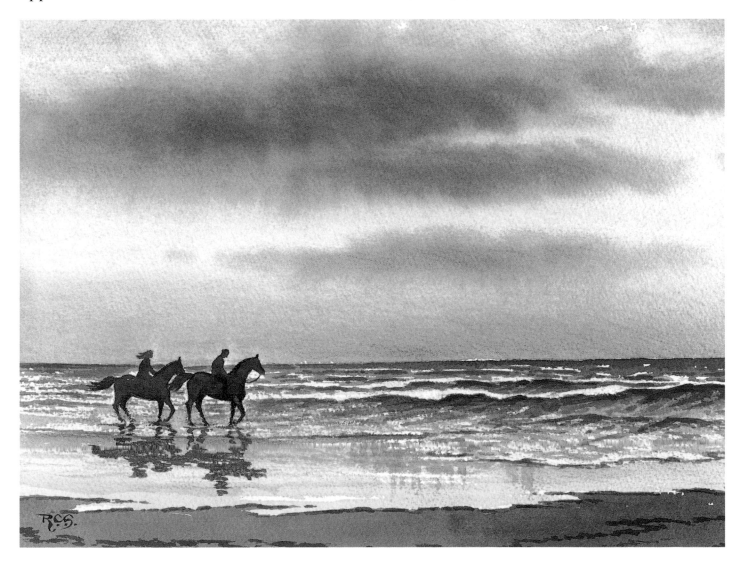

Materials and techniques

Before we get down to the all-important subject of watercolour technique, we must consider materials, for correct choices here affect our work for good or ill. Art materials are expensive, and many artists are understandably tempted to make do with second best, but this is often false economy. Inferior papers, in particular, can be a real hindrance to progress. This first chapter also deals with the principal watercolour techniques – flat, graded, variegated and broken washes, wet-in-wet and drybrush work – showing just what they are and how to use them effectively in your own work.

AUTUMN FIELDS
The rich colours of the trees and fields are created from a comparatively limited palette, and the billowing cumulus clouds have highlights of white paper.

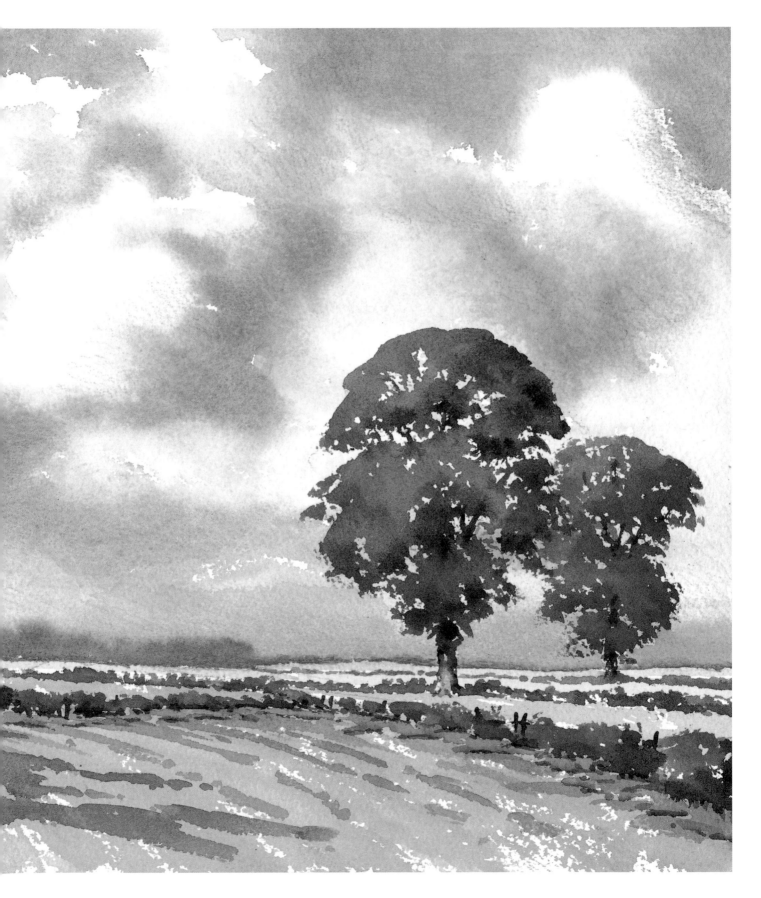

Basic materials

Paints

At the start of any discussion about watercolour paints, two questions immediately present themselves: whether to use tube or pan colours, and whether to opt for artists' or students' quality. To answer these questions, let me tell you what I do. I use a paintbox with 12 full-size pans, which I find ample for my limited palette and in addition more convenient, as well as less wasteful, than squeezing tube colour on to a mixing palette.

That said, I prefer tube colour for its softness and greater responsiveness, so before starting a painting, I squeeze tube paint of the colours I propose to use into the appropriate pans. In this way I have the convenience of pan paint with the advantages of tube paint. An added bonus is that the new paint freshens up the old, so nothing is wasted.

The second question is partly a matter of cost, for artists'-quality paints are naturally more expensive than the students' variety. My own feeling is that they are worth the extra payment for their greater brilliance and clarity and, after all, watercolourists do not apply paint with the lavish abandon of painters in oils, so the difference in expenditure per painting cannot be very great.

It is worth mentioning that there are today many imported paints, manufactured all over the world, which are competitively priced. I have tested most of these for art magazines and have found the majority very satisfactory, so it may pay you to shop around until you find the range that you feel happiest using.

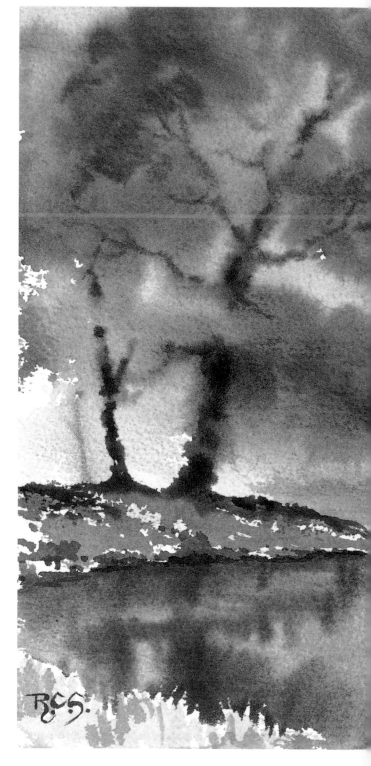

MISTY RIVER
Misty, soft-edged effects are easier to achieve by using the best paints you can afford, and by experimenting with different paper surfaces to determine which one suits a particular subject.

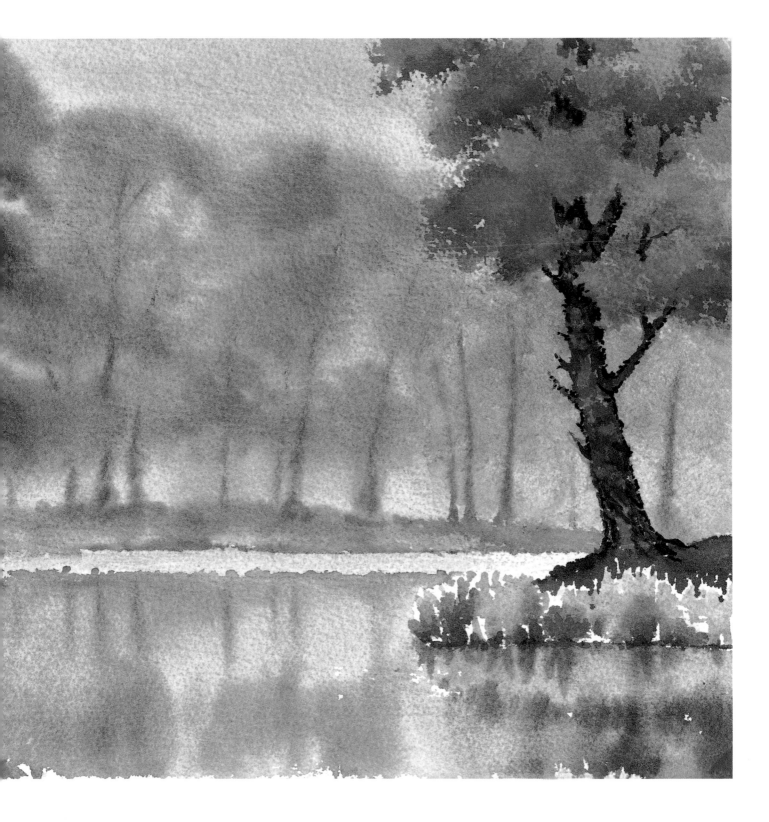

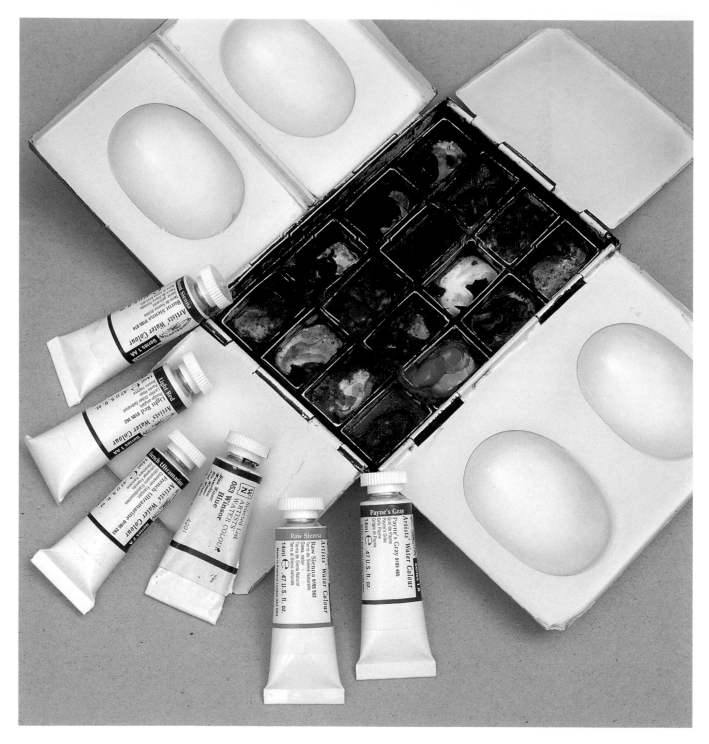

Palette of colours

I would urge you to restrict the number of colours you regularly use. With a smaller number, you get to know their individual properties more intimately, and you will find that paintings containing a narrow range of

WATERCOLOUR PAINT PANS AND TUBES

colours have a way of 'hanging together' far better than those which contain every colour of the rainbow. For landscape work my palette consists of raw sienna, burnt sienna, light red,

16

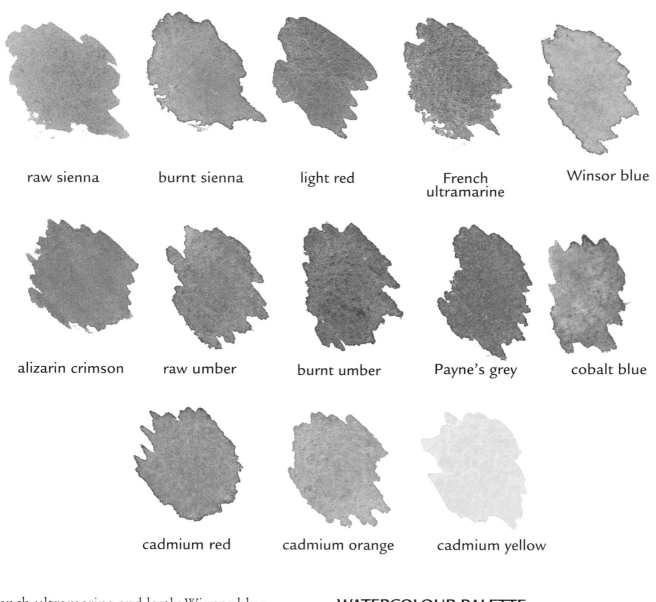

raw sienna burnt sienna light red French ultramarine Winsor blue

alizarin crimson raw umber burnt umber Payne's grey cobalt blue

cadmium red cadmium orange cadmium yellow

French ultramarine and lastly Winsor blue. I sometimes add alizarin crimson, raw and burnt umber, cobalt blue and Payne's grey to this list, according to the requirements of my subject, and for sunnier climes, the cadmiums – red, orange and yellow. The choice of colour palette is a very personal thing, and there is no correct range of colours. It is sometimes helpful in the early stages to adopt the palette of an established artist whose work you admire. As your experience grows and your own preferences emerge, you will make changes.

WATERCOLOUR PALETTE
Top row: *my 'landscape' palette.*
Middle row: *additional colours for particular subjects.*
Bottom row: *additional colours for sunnier climes.*

Paper surfaces

The quality of the watercolour paper you use is of the utmost importance and influences your work for good or ill, so go for the best paper you can afford. There are two considerations, in addition to price – type of surface and weight. There are three types of surface: Smooth (or HP, for hot-pressed), Not (or CP, for cold-pressed) and Rough. I rarely use the first and find that its surface lacks 'tooth', although it can be useful for very precise work and for line and wash. Not is the most widely used surface, and is suitable for most purposes. My preference, particularly for landscape subjects, is the Rough surface; I find that it aids such techniques as broken washes and drybrush work, and is particularly useful for capturing the broken outlines of foliage.

Paper weights

Weights of paper are measured in pounds (or grams) per ream of imperial sheets and generally range from 90lb (180gsm) to 300lb (600gsm). The heavier the paper, the more resistant it is to cockling when liquid washes are applied. In general, anything under 200lb (410gsm) should be stretched to prevent excessive cockling, a state of affairs that gives rise to uneven drying and other related problems.

The best papers are made from pure cotton rag and are expensive. There are perfectly satisfactory papers on the market manufactured from wood pulp, and these are naturally less costly. My favourite rag papers are Arches and Saunders Waterford, 300lb (600gsm) Rough in both cases. The less costly, lighter weights provide an excellent working surface when stretched and are well worth the expenditure of time and money. Of the wood-pulp papers, my choice is Bockingford, which responds well to the liquid watercolour technique.

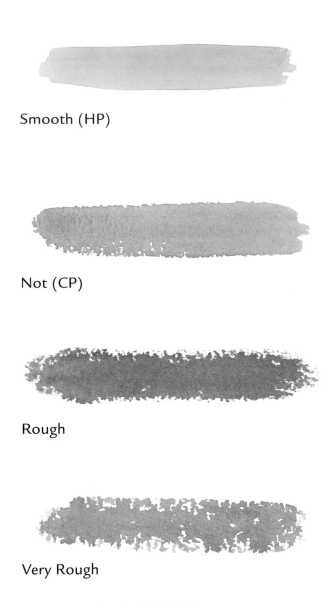

Smooth (HP)

Not (CP)

Rough

Very Rough

WATERCOLOUR PAPERS

TIP
The surface of Rough watercolour papers aids the production of textured effects, broken edges and the like.

Stretching paper

Stretching watercolour paper is not difficult. Simply immerse the paper for 5 minutes or so in clean water, then hold it by one corner to allow the surplus water to drain off, lay it on a flat surface such as a drawing board and, with a soft cloth, gently smooth away any air bubbles, remembering that the wet paper is extremely vulnerable to damage. If surface damage does occur, it will impair the clarity of subsequent washes, causing dark stains to appear. Stick down all four edges with gummed tape (not masking tape), allowing the tape to overlap the paper by about 1in (2.5cm), and leave it to dry overnight. The following day the paper will be flat, tight and ready for use. Any slight cockling that may occur when liquid washes are applied will be minimal.

1 *Immerse the paper in clean water.*

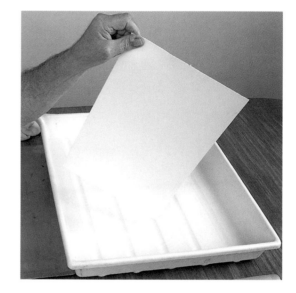

2 *Allow surplus water to drain off.*

3 *Smooth away air bubbles under the paper.*

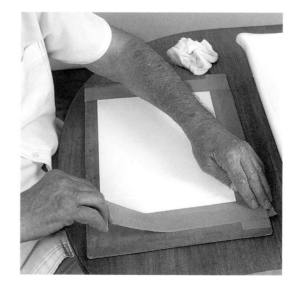

4 *Stick the paper down with gummed tape.*

PART 1: MATERIALS AND TECHNIQUES

Brushes

You do not need a wide variety of brushes and can get by with three or four, for example a 1-in (2.5-cm) flat, or if you prefer, a mop for large areas such as skies, a No 12 round, a No 8 round and perhaps a rigger. It pays to buy good-quality brushes, both for their performance and for their lasting properties. The best brushes are undoubtedly those made from Kolinsky sable, but their high price means that most painters have to consider alternatives, of which there are many available. Some of the synthetics are admirable, as are some of the blends of sable and synthetic, and these are a fraction of the price of pure sable. As you become more experienced you will add to your range of brushes, and if you wish to loosen up and avoid tightness in your work, go for the larger rather than the smaller sizes.

Accessories and extras

With paintboxes, avoid expensive sets that have dozens of different colours – an excessively wide range is both confusing and unnecessarily costly. A dozen or so is all you will need, at least in the early stages. There is no need to spend lavishly on elaborate mixing palettes, and white kitchen plates or butchers' trays are effective.

There are many ways of producing texture, such as sprinkling salt or sand on to a wet wash, but I prefer to obtain such effects with time-honoured watercolour techniques (see pages

BRUSHES
From top to bottom:
No 12 round, No 8 round, rigger, mop, 1/2-in (1.25-cm) flat, 1-in (2.5-cm) flat.

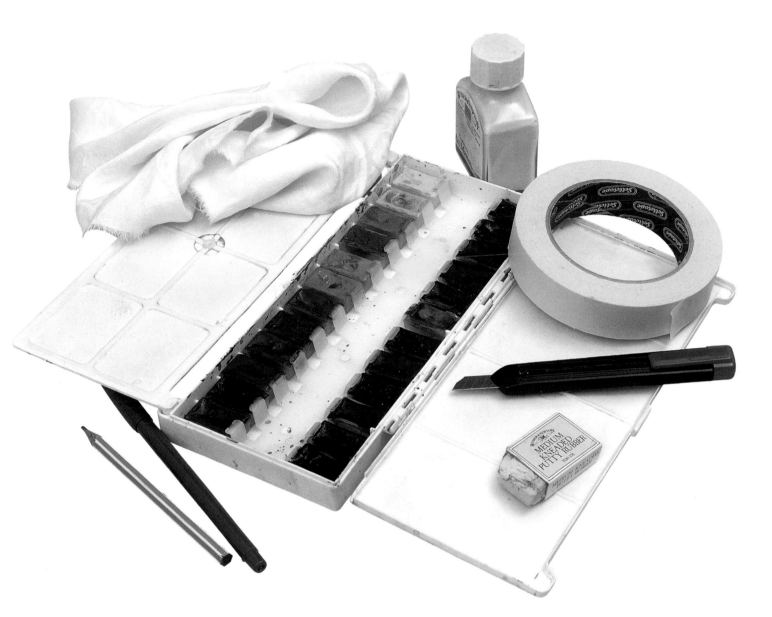

28–53). Masking fluid, however, can be most useful for preserving white paper against a dark background, for instance the white sails of a windmill against a stormy sky. Soft pencils, 2B or 4B, are preferable to hard grades, as they do less damage to the surface of the paper, and a putty eraser is preferable to an India rubber or plastic version for the same reason.

A wooden drawing board is necessary as a support for any watercolour paper. If you like working at an easel, choose one of the excellent light metal models on the market, but if you prefer painting seated, with the drawing board

ACCESSORIES
Watercolour paintbox with pencil, felt-tipped pen, cloth, masking fluid, masking tape, craft knife and an eraser.

on your lap, a light folding stool is all you need. With the board on your lap, you can control the flow and direction of liquid washes when necessary, and this is a very real advantage. A generous-sized water container, some clean rag or kitchen tissue, a sharp knife, and the list is complete, though a Thermos flask and some insect repellent may add to your comfort.

Aids and additives

Every book on watercolour painting should contain at least some information on what are usually referred to as 'aids' or, by those traditionalists who do not approve of them, as 'tricks'. They include a wide variety of materials which, it is claimed, make the painter's task a little easier by producing effects it would be difficult to achieve in any other way.

Opinions differ widely on the usefulness of artificial aids. Purists maintain that the watercolour medium, used with skill and in the traditional manner, can do all that is necessary, and that 'tricks' only serve to produce flashy and facile results. Those in the opposite camp believe that the medium is difficult enough and that the use of anything that helps the painter to achieve interesting effects is entirely justified. One thing is certain – such aids will never mask poor painting technique, and they should be handled with subtlety and discrimination, otherwise the result is bound to look contrived and artificial.

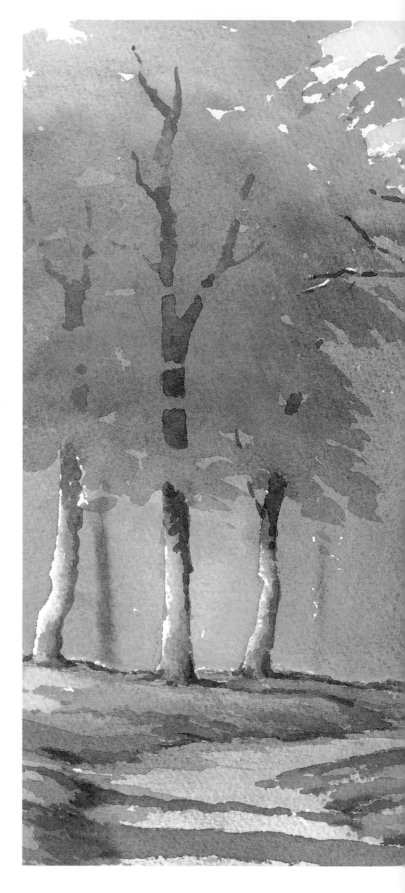

BEECHWOOD

One way to save time painting around complex images is to use masking fluid to preserve the required shapes.

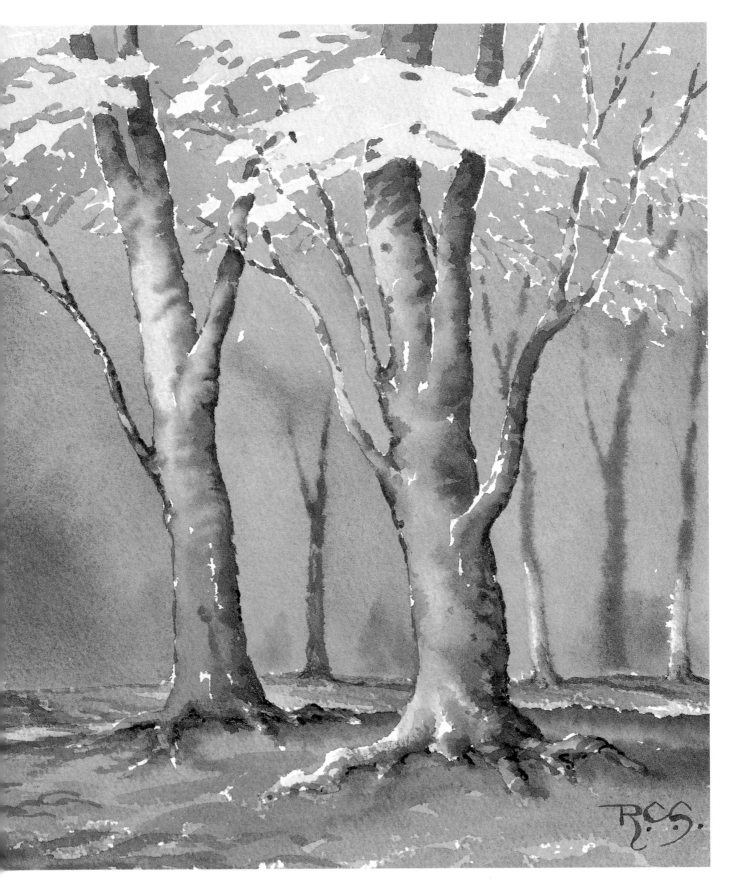

Types of aids

A variety of different materials or products, as well as implements, can be used to achieve different results. They can be broadly grouped under five main headings:

■ Resists, such as masking fluid, masking tape and candle wax, act as a barrier to the applied paint, to protect particular areas.

■ Texturing additives, such as salt, sand, rice and so on, can be sprinkled on to a wet wash to produce, on drying, an impression of texture. Liquid additives, such as alcohol, turpentine and liquid soap, can also produce a variety of effects when used in conjunction with watercolour.

■ Sponges are used both for applying and removing liquid washes, and screwed-up materials of various kinds produce random patterns when pressed on to a freshly applied liquid wash.

■ Tools, such as knives, scalpels, razor blades and other sharp implements, can be used to scratch off dried pigment in order to reveal white marks and lines, or areas of texture. Sandpaper is also sometimes used for the latter purpose.

■ The final group is perhaps best described as miscellaneous and includes almost anything you care to press into service – leaves, string, card, bubble wrap, strongly textured fabrics and so on.

Resists

Masking fluid is a form of liquid latex which can be applied to the painting by brush or pen.

Examples of fine shapes that have been preserved by using masking fluid.

When the fluid is dry on the paper, it may be painted over with safety, and when the painting itself is dry, masking fluid can be removed with a finger or a rubber. It will come away readily enough in little rubbery rolls from most papers, but some soft-textured surfaces are vulnerable and lose fibres when the latex is removed in this

Apply horizontal strokes of a wax candle to act as a resist and suggest light sparkling on water.

way. It pays, therefore, to test the masking fluid on an offcut of the paper first.

Masking fluid is of particular use when you want to preserve fine shapes in the middle of an area of a broad wash, for instance a flight of white doves against a dark and stormy sky, where the quality of the wash will suffer if you have to spend time carefully painting around complex images.

When applying masking fluid by brush, it tends to clog the base of the brush hairs at the point where they enter the ferrule, so only use old or cheap brushes. It helps a little if, before use, you moisten the brush head with liquid soap. Larger areas can be more economically preserved with masking tape, and only shaped edges treated with masking fluid.

Masking fluid can be spattered on to the surface of the paper with the aid of an old toothbrush or stencil brush, perhaps to suggest

pebbles in a gravel path or even wild-flower heads in a meadow.

When a candle is drawn firmly across paper, the points of contact become resistant to watercolour. On Rough surfaces the effect is broken, but on Smooth surfaces it is naturally more continuous. Paper protected by masking fluid can be painted over when the dried latex has been removed, but paper treated with candle wax remains resistant.

TIP
Diluting masking fluid with about half its volume of water makes it easier to use, without impairing its masking properties.

Salt sprinkled on to a wet wash.

Sand sprinkled on to a wet wash.

Rice sprinkled on to a wet wash.

Texturing additives

When salt is sprinkled on to a freshly applied wash, each grain attracts the water but repels the pigment and so, when all is dry and any surface debris has been brushed away, tiny, flower-like shapes appear. Grains of sand have a different effect, tending to attract the liquid wash, and the result here is dark rather than light. When rice grains are sprinkled on to a wet wash, the pigment tends to gather round the individual grains, and when all is dry and the rice grains are brushed off, the effect is similar to that of shingle.

Sponges

Sponges are commonly used to blot out areas of applied wash in order to lighten the tone of certain areas; this method is often employed to indicate the presence of clouds. They can also be used to apply colour, and many painters find that this is an easy and reasonably effective way to capture the form and outline of foliage.

Foliage indicated by paint applied with a sponge.

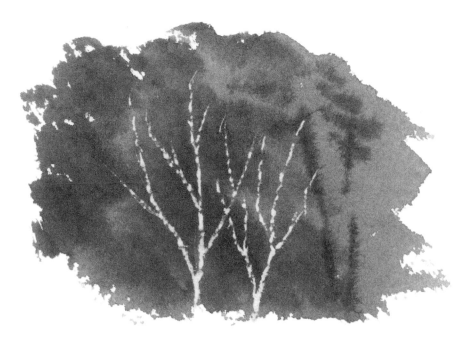

Twigs can be scratched out of a background with a scalpel blade.

Sharp tools

Implements such as scalpels and craft knives are widely used to capture a variety of effects, such as highlights, twigs and grasses against a dark background and so on, but while the effect is usually crisper and more satisfactory than using white body colour, the technique should be used with due restraint or the result can become repetitive and tedious.

Other effects

Some objects that are frequently used to create particular textured effects, such as bubble wrap and embossed fabrics, create a repetitive pattern which looks thoroughly artificial and is alien to good watercolour practice. On the other hand, the straight edge of a piece of card to which liquid paint has been applied can effectively represent poles, masts of sailing boats and the like: these marks will appear looser and less precise than a similar brushstroke.

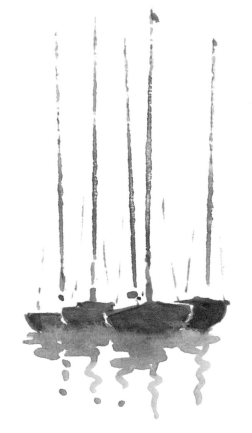

Use a straight-edged card to 'paint' masts of sailing boats.

Introducing washes

A wash is simply a little pool of water with paint mixed into it. Naturally, the more paint you add, the stronger the resulting colour will be, and one of the things to learn is how to prepare a wash of exactly the strength you require. This comes with experience, but in the early stages it is wise to test washes on scrap paper first, rather than risk having to strengthen or dilute them once they have been applied, for, as we have seen, this can compromise their freshness and transparency. Another way in which clarity may be jeopardized is to use too many colours in one wash or to press leftover washes of uncertain origin into service. There is no need to use more than three colours in one wash, and your aim should be not to exceed that number.

Beginners often imagine that washes are only needed for the larger areas of the painting, and are apt to paint straight from the pan for the smaller parts. In truth, every passage of the painting should be captured in a fresh, clear wash, and this means the preparation of well-mixed washes, even for the smallest areas.

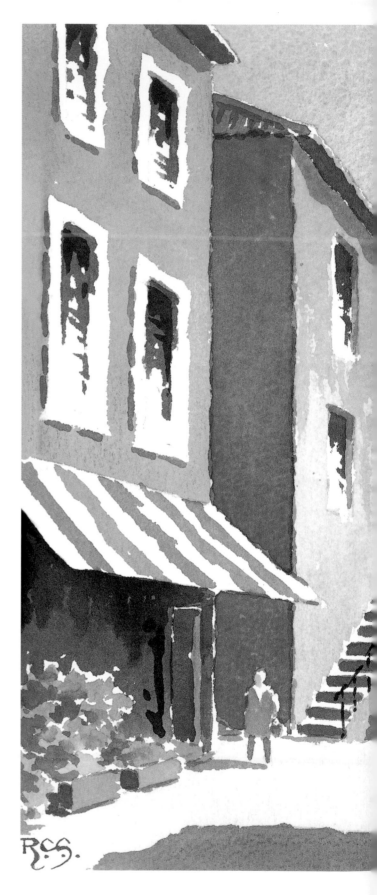

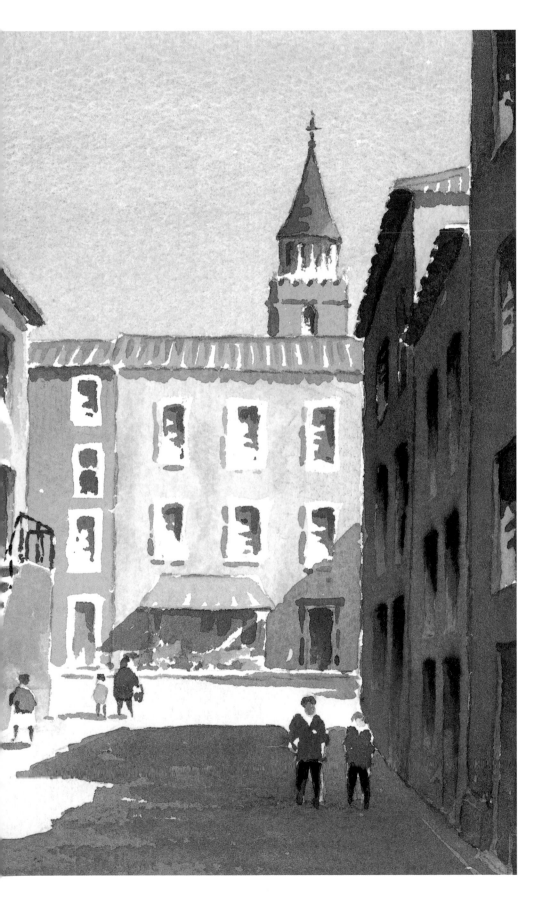

STREET CORNER, PROVENCE

The clear sky and strong sunlit effects in this quiet street scene are produced by flat washes.

29

Flat washes

The simplest of the washes is the flat wash, where the desired colour is spread evenly over the designated area to produce a regular, uniform result. This is easy enough when the area is a small one, but problems can arise when a large expanse, such as a sky, has to be covered; however, there is a technique for getting over this problem. First, thoroughly mix a pool of the required colour, making sure that it is large enough for your needs, since running out of wash before the completion of the passage is fatal – by the time you have prepared an extra pool, drying may have already begun and the chances of obtaining an even result have disappeared. What is more, the second wash may not be a perfect match for the first, especially if you are using more than one colour. In this context it is always better to overestimate your needs, even at the expense of some wastage.

Now add pigment, a little at a time, until you are satisfied with the strength of the wash. If you begin with too much paint, particularly if it is one of the stronger, staining colours, you may have to add so much water to dilute the wash that much of it will be wasted.

Drawing board at a suitable angle for applying a wash.

The next step is to ensure the drawing board to which your watercolour paper is pinned or taped is at a suitable angle. If you are using an easel, this is not a problem but if you are working on a flat surface, angle slats fixed to the back of your drawing board will do the trick. The angle of your board is a matter of personal choice and artists' preferences certainly differ considerably. In general terms, if the angle is too steep, washes will stream down the paper out of control, but if the gradient is too slight, the effect of gravity will be insufficient for this technique to work properly. I have found an angle of about 15 degrees from the horizontal about right, but much will depend upon your painting style and, to a lesser extent, upon the surface of your chosen watercolour paper. A very loose and liquid style generally needs less gravity, while an absorbent paper surface needs rather more. It is worth experimenting to find an angle which suits you.

A regular, uniform flat wash.

NEAR ST TROPEZ
Flat washes were initially applied to the colour-washed buildings. When these were dry, smaller washes of warm grey were added here and there to suggest texture and weathering.

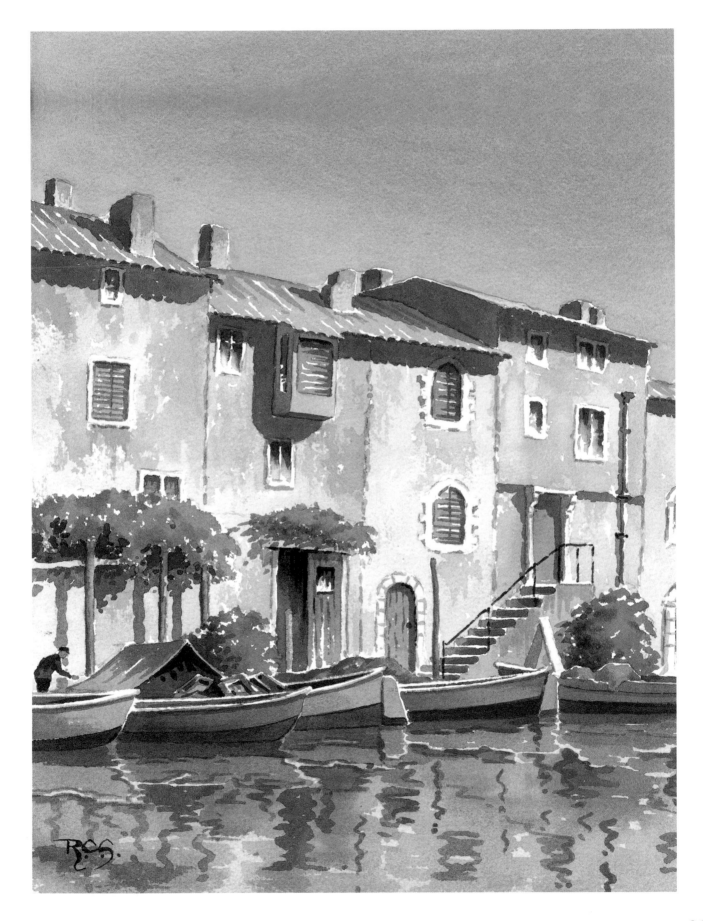

1 *Apply the first bold, horizontal stroke.*

2 *Start the next stroke at the other side.*

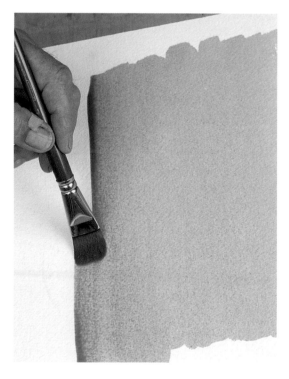

3 *Continue working from side to side.*

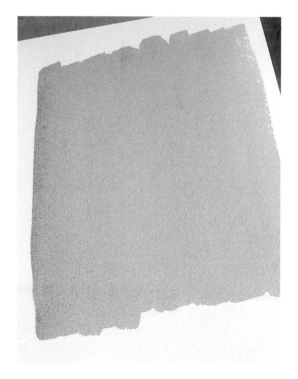

4 *The finished flat wash.*

Apply the wash in a bold, horizontal stroke right across the top of your paper, using a large brush such as a 1-in (2.5-cm) flat or a mop. The angle at which you are working ensures that the surplus wash flows down the paper to form a long bead at the lower margin of your stroke. Repeat the process with a second horizontal stroke which picks up the surplus wash from the first.

Carry on in this way down the paper until the required area has been covered, aiming to achieve a smooth and uniform colour. I usually begin each successive stroke from the opposite side of the paper to the one before, which prevents one side ending up slightly darker than the other.

A common reason why inexperienced painters do not always achieve perfection when laying washes is because they work so tentatively and slowly that premature drying frustrates their efforts, and the finished wash has a rather uneven and stripy appearance. With growing confidence and greater speed of working, however, this problem usually disappears. If it does not, a better result may be obtained if you dampen the whole area to be painted with clear water, mixing a slightly stronger wash to compensate for the diluting effect of the damp surface. This method is also useful when working in a hot, dry atmosphere or when using a particularly absorbent type of watercolour paper.

In practice you do not often need such a large expanse of evenly applied colour. Clear skies, for example, are never the same tone or colour throughout, and usually become paler and warmer in colour towards the horizon. Practice in laying washes is always useful, however, and helps you learn how to control both the brush and the paint.

Practice exercise
LAYING A FLAT WASH

This is an essential skill which you should acquire early in your quest for mastery of the medium. If you follow the simple rules and work quickly with a full, liquid wash, you will produce a smooth, even result like the example below. Now put your technique to the test!

Materials
Sheet of watercolour paper
1-in (2.5-cm) flat brush
Paint wash

1 Pin the paper to a drawing board set 15 degrees from the horizontal.

2 Apply a well-mixed wash in bold horizontal strokes across the top of the paper.

3 Carry on down the paper, picking up the bead of liquid from the previous stroke and alternating the direction of the brushstrokes.

Other washes

As we have seen on the previous pages, the flat wash is normally suitable for depicting clear skies only when a comparatively small expanse is visible. Skies are usually paler and warmer in tone as they approach the horizon, and so other techniques must be employed to capture such gradations of tone and colour. This is where the graded wash and the variegated wash come into their own.

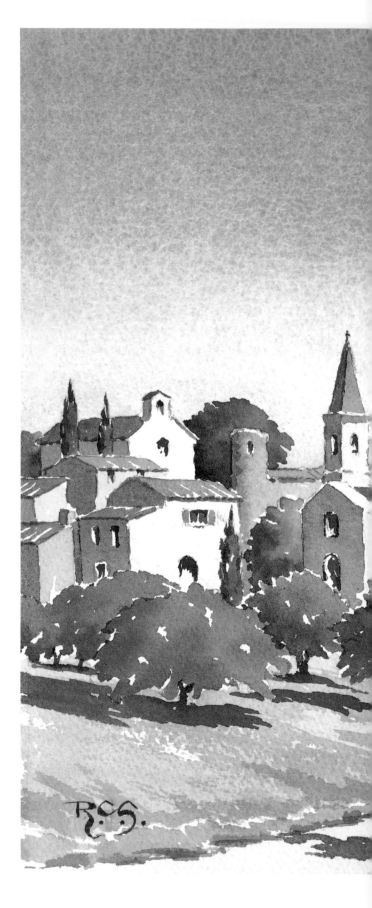

ST GILES, PROVENCE
*Here the sky is a variegated wash —
the blue gradually merges into a paler,
warmer colour towards the horizon.*

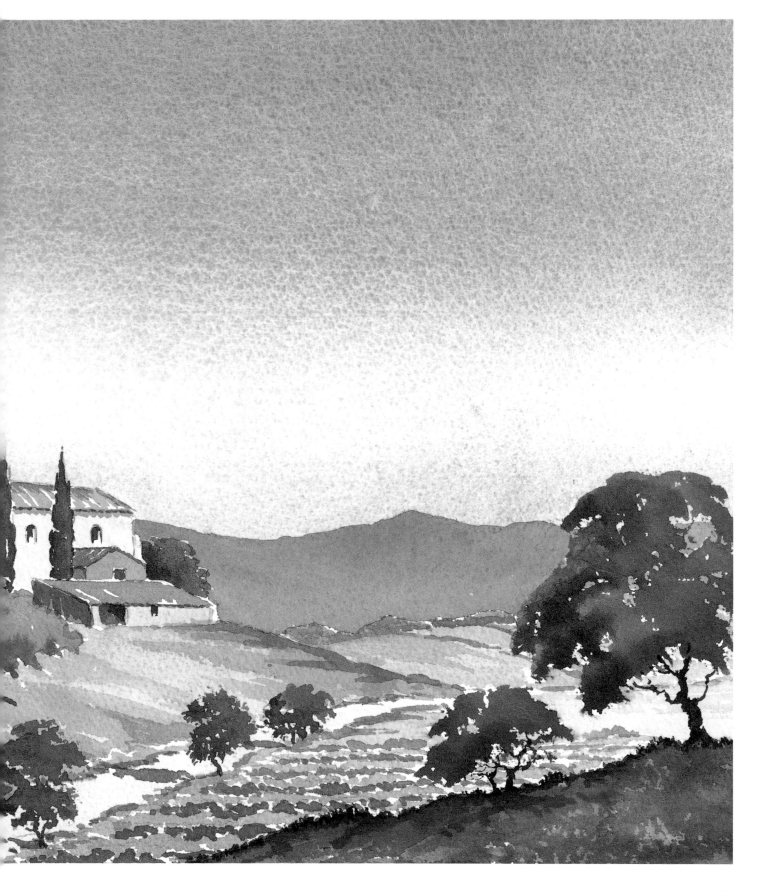

Graded washes

Just like the flat wash, the graded wash consists of one colour, but unlike the flat wash, this colour is not evenly spread but changes in tone. To produce this effect, prepare a well-mixed pool of your chosen colour of the required strength and begin, as with the flat wash, by applying bold horizontal brushstrokes right across the top of the paper, which is set at an angle of about 15 degrees from the horizontal. Continue, but dipping the brush into clean water instead of the wash, thus progressively diluting the colour remaining on the brush, so that the wash gradually pales as you work down the paper.

1 *Apply the first stroke across the paper.*

2 *Dilute the colour with clean water.*

3 *Continue diluting the wash with water so that it gradually pales.*

This technique is not quite as easy as it sounds, and some skill is necessary to achieve a gradual paling of colour. If, in the early stages, you dip an almost dry brush into the pure water, the transition from dark to pale is too abrupt. The trick is to ensure that the proportion of water to pigment on the brush increases only gradually and then the transition from dark to pale will be smooth and regular.

There is likely to be some trace of the original colour on the brush at the end of this process, so if you want the final washes to be just the white of the paper, reverse the process, starting with horizontal strokes of pure water and then picking up increasing amounts of the coloured wash as you go. The graded wash can be used in any part of your painting where you want to achieve a gradual lightening of the local colour.

Graded washes.

SAILING BARGE AT ANCHOR
A smoothly applied graded wash of pale Payne's grey was used for the sky; the water below was another graded wash to which I added the hard-edged reflections, wet on dry.

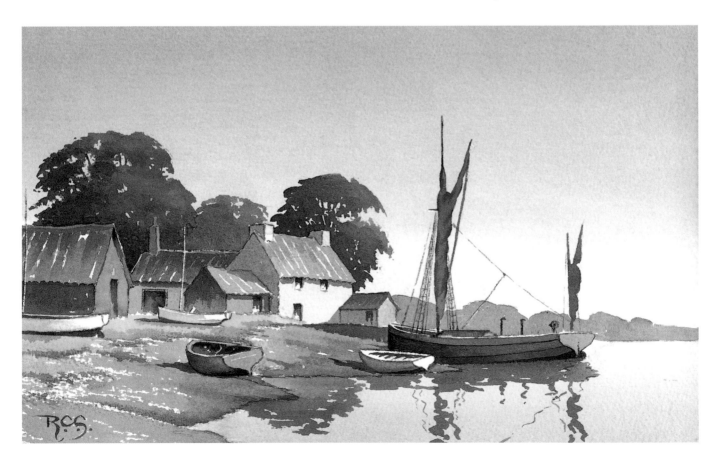

Variegated washes

The variegated wash is similar in many ways to the graded wash but, instead of gradually adding water, you add increasing amounts of a second wash of a different colour – so instead of a progressive paling of the first colour, there is a gradual blending of it into the other colour. Prepare two pools of well-mixed colour in advance, and make the initial bold brushstrokes across the top of the paper with the first colour. With the subsequent brushstrokes, less of the first wash and more of the second is taken up, which gradually changes the colour from that of the first wash to that of the second. If the application is skilfully carried out, the gradual transition of the first wash to the second is smooth and regular.

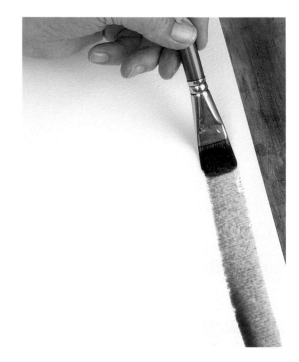

1 *Apply the first colour.*

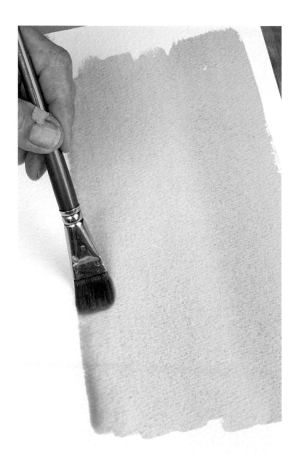

2 *Gradually add the second colour.*

3 *The finished variegated wash.*

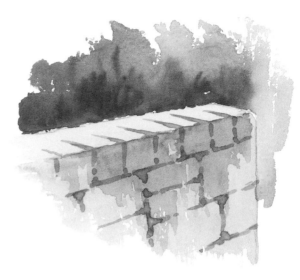

Variegated washes.

Additional washes can provide texture.

The single pool of colour for the graded wash and the twin pools of colour for the variegated wash can be mixed from just one pan or tube of paint, or from two or even three, according to the colour required. The strength of each wash can also be varied, again according to the needs of the painting.

Using multiple washes

While, as a general rule, it is better to say what you have to say in one wash rather than two or more, there are occasions when you have to employ more than one. A roughcast wall, for example, rendered in one wash, may look clear and fresh, but it may also look a bit too bland and so requires a second wash of some kind to give it form and texture.

Glazing washes

In another context, you may feel that a painting has failed to reflect the evening glow of your subject, and this is where an overall wash of a suitably warm colour can give it the lift it requires. A word of warning here, however – a

glazing wash, as it is termed, must be applied with the utmost delicacy on a completely dry surface, with a large, soft-textured brush, or the underpainting may be disturbed and the painting ruined. Some painters gradually build up their effects by applying successive pale glazing washes. While this technique works well in the hands of experts, the safest way to ensure clarity and luminosity is via the single wash. However, as you become more experienced and proficient, you will be confident enough to experiment – and this is where the fascination of watercolour really begins!

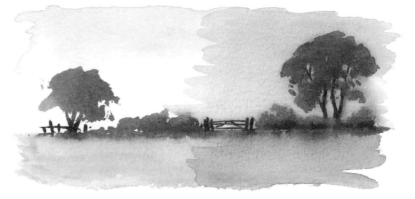

The effect of a glazing wash can be seen on the right.

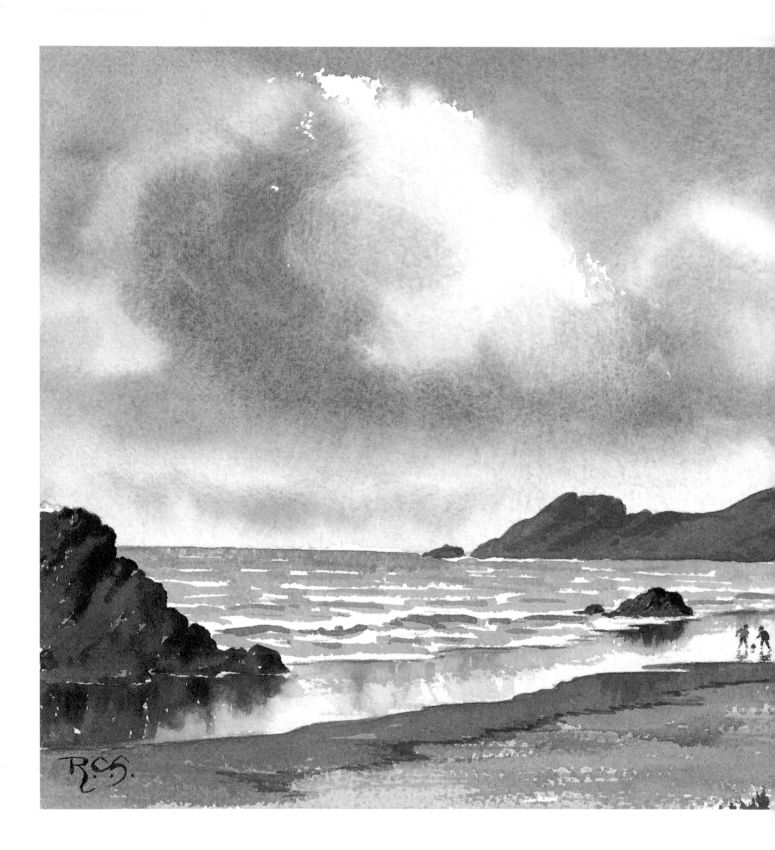

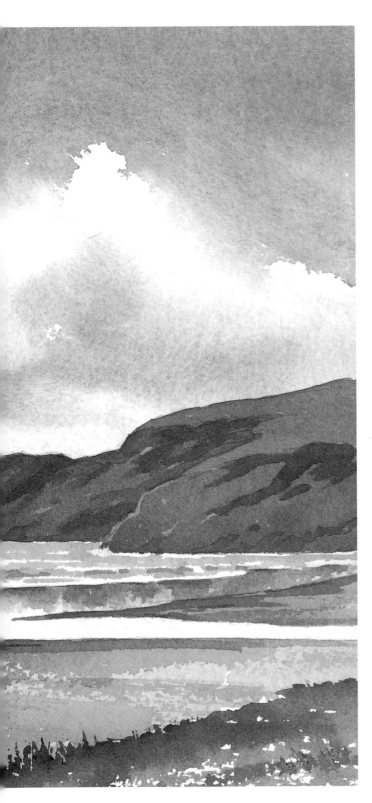

HOPE COVE
The sand and grass in the foreground are painted with broken washes (see page 44), and the subtle colours of the clouds with variegated washes.

Practice exercise
LAYING A GRADED WASH

This technique is very similar to that of the flat wash, but about halfway down the paper start to dip the brush into pure water instead of your prepared wash. If you are attempting a variegated wash, dip your brush in your second prepared wash instead of pure water.

Materials
Sheet of watercolour paper
1-in (2.5-cm) flat brush
Two paint washes of different strengths or colours
Jar of clean water

1 With watercolour paper pinned to a board set up at a suitable angle, start to apply your wash with bold, horizontal strokes, alternating the direction of the strokes.

2 About halfway down the paper, dip your brush in pure water and continue.

3 The result should be a smooth and gradual lightening of the tone, as in the example below.

4 Why not now prepare two washes of different colours and try your hand at a variegated wash?

Capturing texture

Foregrounds are a source of difficulty for many painters, largely because their very proximity presents a mass of detail which can be seen all too clearly. While a middle-distance field can be effectively described by a bold, horizontal wash of the appropriate colour, a foreground meadow is another matter. The innumerable blades of grass, seed heads and wild flowers are too close to be ignored, and a flat wash hardly begins to capture their form and texture.

Once you begin to paint this foreground detail, problems arise. You may start by putting in a few scattered clumps of meadow grass and flowers, only to find the spaces between them begin to look even more uninteresting and flat. If you then fill in these gaps with more of the same, before long every inch of the foreground is covered in painstaking detail and the more you try to improve it, the more overworked and tired it will become.

Likewise, in a coastal scene with a stretch of shingle in the foreground, a flat wash would give no clue to the texture or form of the stony material, but once you start to paint individual pebbles, an excessive amount of detail and overworking is almost inevitable. The answer lies in finding some means of suggesting the foreground in a simple, direct manner, without resorting to over-elaboration.

LAVENDER HARVEST

The texture of the rows of lavender contrasts with the variegated wash of the sky and the similar-coloured, but smooth, hills.

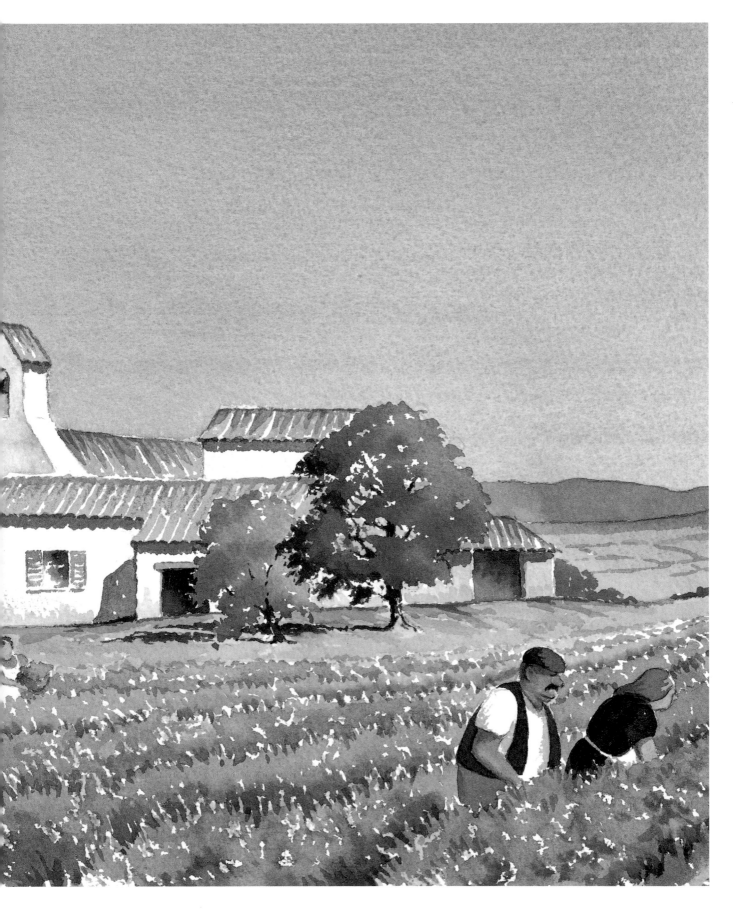

Broken washes

As its name suggests, this wash is applied in such a way that not every part of the paper is covered, and there are little gaps and strings of white dots where the brush has failed to make contact with the tiny hollows in the surface of the paper. When the wash is properly applied, these scattered white spots give a reasonably effective impression of texture.

A broken wash.

Naturally, this impression is not nearly so precise and literal as is carefully painted foreground detail, but it is bolder, and more spontaneous and painterly. It may need a little added information to suggest form, in the shape of darker accents added here and there, but these should be kept to a reasonable minimum, or overworking will again creep in. If the white of the untouched paper is a little too startling for a particular type of foreground, a pale preliminary wash may be necessary, applied and allowed to dry before the application of the broken wash.

A broken wash applied over a preliminary wash.

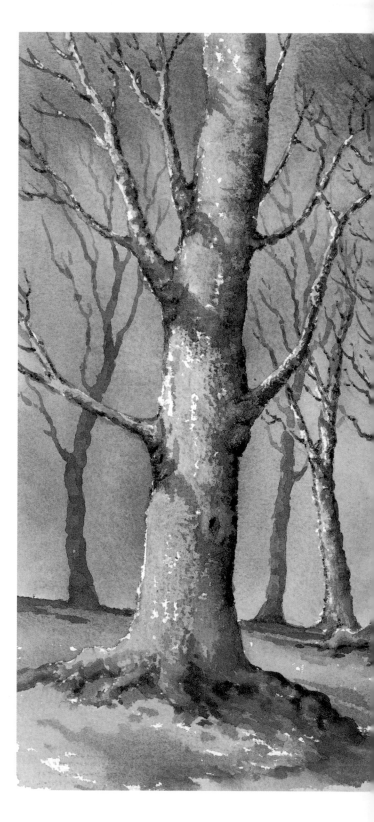

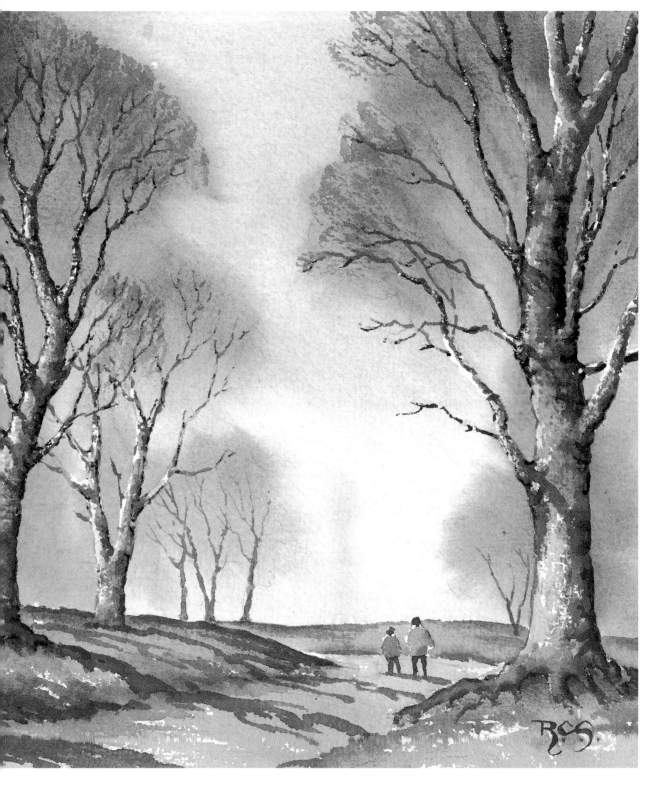

BEECHWOOD IN WINTER
*The rough bark of the trees in the foreground
and middle distance contrasts with the misty,
soft-edged treatment of the remaining leaves.*

The pool of colour prepared for a broken wash should be slightly less liquid than for flat, graded and variegated washes, and should be applied to the foreground with bold, horizontal strokes of a 1-in (2.5-cm) or a $^1/_2$-in (1.25-cm) flat brush or a large round brush held almost parallel to the paper and drawn rapidly across the surface without too much pressure being applied. This technique works best on a Rough paper, but it is possible, with practice, on a Not surface. It takes a little time to master this technique, but you soon learn how to prepare a wash of the right consistency, how fully to load the brush, and then how to drag it lightly across the surface of the paper in order to achieve the desired result.

Meadow grass

Shingle

Light sparkling on water

Three broken washes.

Broken washes can be used for many other purposes than suggesting foregrounds – they can be used to indicate the textures of old stone masonry, weathered brickwork and much more, perhaps in conjunction with drybrush work. Practise broken washes for yourself – they are a most useful technique which you should add to your repertoire.

1 *Apply the paint at an acute angle to the paper.*

TIP
Drybrush technique works best on a Rough surface, often with deep-toned pigments which not only create a strong feeling of texture, but also make the objects register more strongly against the paler tones of the middle and far distance.

2 *Using the broken wash over a large area.*

Drybrush

Drybrush work is useful for suggesting the texture of such objects as tree bark, rock and other rough-textured materials. It is similar in many ways to the broken wash technique, but requires a less liquid pool of colour – if it is too liquid, the pigment fills all the little depressions in the paper's surface and there is no suggestion of texture; on the other hand, if the mixture is too dry, freshness and clarity are lost and the result looks a little muddy. As with broken washes, the brush is drawn rapidly over the surface of the paper, engaging the little hills, but missing the little valleys.

Tree bark

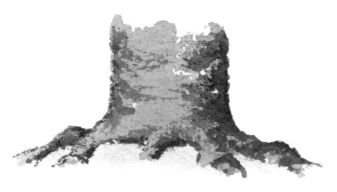

Old brickwork

Two examples of drybrush technique.

Practice exercise
LAYING A BROKEN WASH

Smooth washes are fine for many subjects, but the most useful technique for suggesting a textured surface is the broken wash. Here, not every part of the paper is covered and many of the little hollows in the paper's surface remain white. Have a practice run yourself, remembering that the brush should not be too heavily loaded.

Materials
Sheet of Rough watercolour paper
1-in (2.5-cm) or 1/2-in (1.25-cm) flat brush
Paint wash

1 Dip the brush into the prepared wash, but do not overload it.

2 Hold the brush at a very slight angle to the paper – almost parallel to it – and draw it quickly and lightly across the paper.

3 Did it work for you? If the result was too solid, your brush was probably too fully loaded or you were pressing too hard. Have another go with a lighter touch.

Wet-in-wet

Wet-in-wet can produce soft images of great beauty which reflect atmospheric effects to perfection. As its name suggests, this technique simply consists of dropping one colour into a still-wet wash of another colour so that they merge together to produce a soft-edged image. If, for example, you wish to paint an impression of a middle-distance tree in a misty setting, lay down a wash of some pale, warm colour to suggest an expanse of sky just above the horizon and, while this wash is still wet, drop in a rather deeper, greyish mixture for the tree. The grey then merges into the first wash to produce a soft impression.

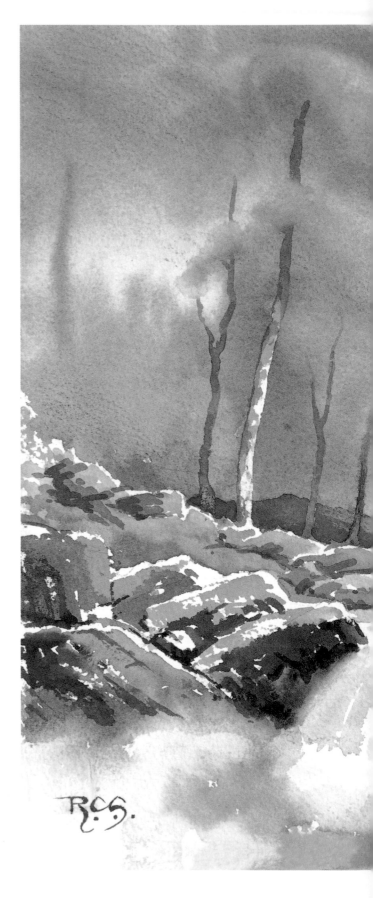

WOODLAND FALLS

Wet-in-wet is the perfect technique for capturing the misty outlines of the trees as they recede into the distance.

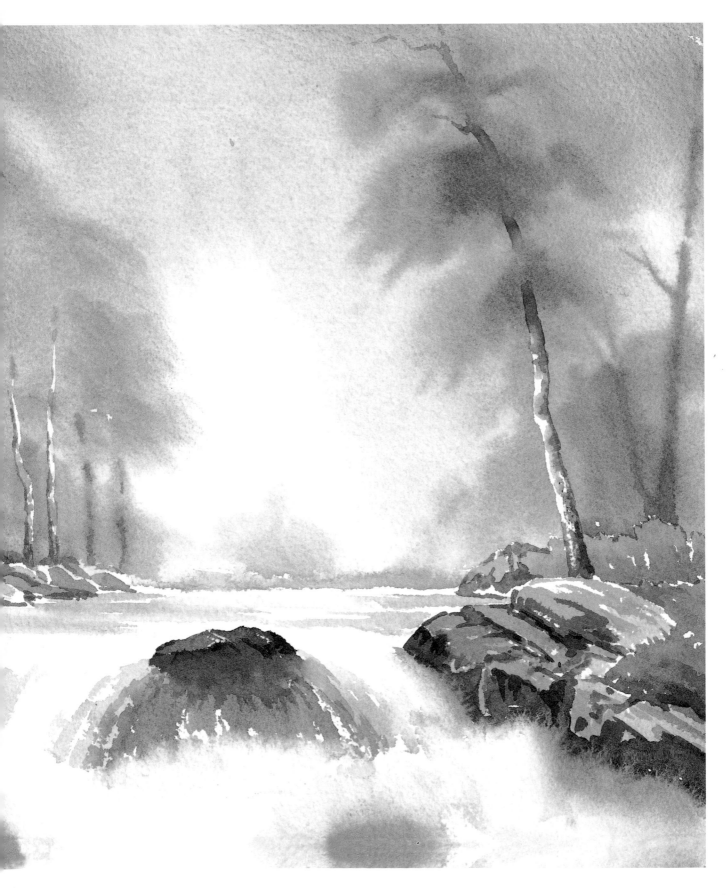

Above and below: *the wetter the underlying wash, the less distinct the finished image will be.*

Timing is all-important in using wet-in-wet, and you need to practise on scrap paper until you know exactly when to apply the second wash. This is often the moment when the shine goes off the first wash, but different makes of paper vary in their behaviour, and only experience and familiarity can ensure a satisfactory result.

If the first wash has not dried sufficiently, the second will be absorbed by it and will be virtually lost to view. At the other extreme, if you delay applying the second wash for even a little too long, an excessive amount of drying will have taken place and hard edges will result instead of soft.

There are, of course, many intermediate stages between these two extremes, but in general terms, the more liquid the first wash is on the paper, the softer the effect of the second; and the less liquid the first wash, the more precise the image created by the second, until, when drying is complete, the effect is completely hard-edged.

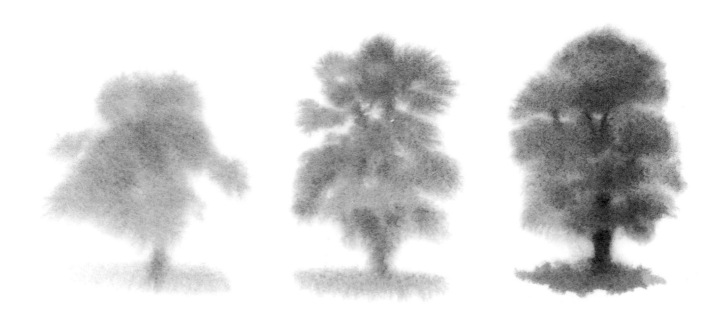

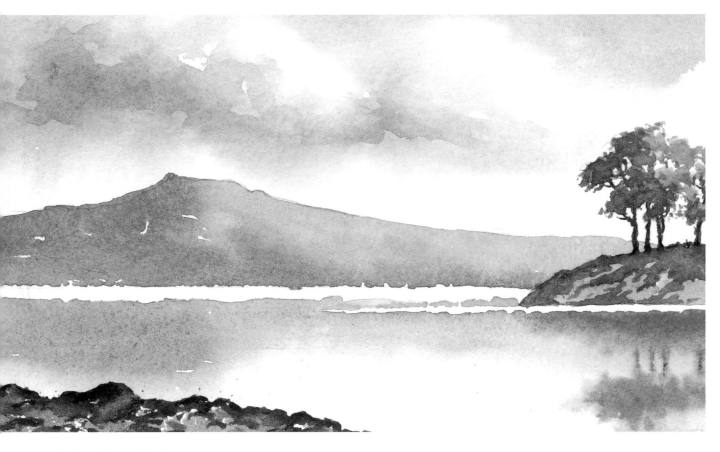

DERWENTWATER
The effects of aerial perspective are shown as tones weaken and colours become cooler with distance.

Aerial perspective

Once you have acquired the skill to vary the softness of edges in this way, you can put it to good use in capturing the effects of aerial perspective. Even on the driest of days, the atmosphere is rarely completely clear – water vapour, smoke and dust all play their part in reducing visibility. On humid days, conditions are naturally mistier, with the objects in the landscape becoming softer in outline as they recede into the distance. Other effects of aerial perspective are reduction in tonal contrast, reduction of tone itself and cooling of colour temperature, and the greater the distance, the more marked these effects are.

TIP

Remember that the second wash should always be less liquid than the first, and you must ensure that this is so. If it turns out to be more liquid, it will spread by capillary action into the first wash, which is by then beginning to dry, until it can go no further. When this happens, the pigment of the second wash is deposited in unsightly concentrations, a disaster that is referred to as 'cauliflowering'.

51

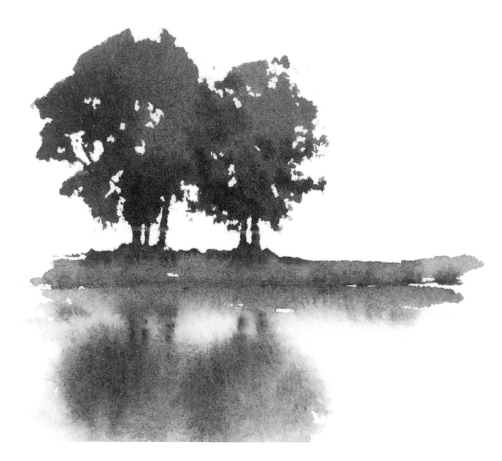

Soft-edged reflections in water.

Wet-in-wet cloud shadows.

Soft edges

The wet-in-wet technique has all sorts of uses in addition to capturing the effects of mist and fog. It is particularly suitable for dealing with soft-edged reflections in water. Soft edges may also be used to indicate movement, perhaps in trees swaying in the wind, to depict the effect of cloud shadows falling over the landscape, and much, much more. Wet-in-wet is especially useful in painting cloudy skies and the soft graduations in tone of cloud shadows.

Wet-over-dry

It is possible to paint a wet-in-wet image over a background that has already dried. Dampen the surface with clean water, judge your moment and then add your desired image in the manner described above. If you try this method, make sure of three things:

■ Ensure that the underpainting is completely dry before applying water to it.

■ Make sure that the water is completely clean, or a tell-tale ring may appear around the edge of the dampened area.

■ Add the soft-edged, wet-over-dry image with the lightest of touch so as to avoid disturbing the underpainting.

Practice exercise
CREATING RECESSION

The illustration below is a quick watercolour sketch of a misty woodland scene in which the wet-in-wet technique has been used. You will see how the colours become ever cooler and paler with distance, and softer in outline. Why not try this subject for yourself? You will need to work quickly, to ensure that everything is completed before the base wash is dry, so be sure to prepare your washes in advance.

Materials
Small sheet of watercolour paper
1-in (2.5-cm) flat or mop brush
Medium brush (No 8 or similar)
Small brush or rigger
Paints: raw sienna, French ultramarine, light red

1 Cover the paper with a pale background wash of raw sienna.

2 While the background wash is still damp, drop in a slightly darker mix of French ultramarine and light red for the soft tones of the most distant trees. For the trees in the middle distance, drop in still deeper tones.

3 When everything is completely dry, add a few still deeper washes for the foreground trees.

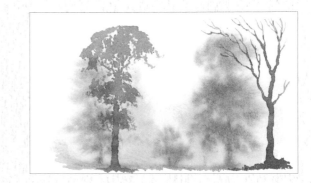

53

Using colour and tone

Whenever I see the results of a group of painters tackling the same landscape subject, I am reminded that we all see colour differently. This difference is reflected in the individual's chosen colour palette, and we recognize the work of established artists not least by their use of colour. Some painters have an innate feeling for colour and know instinctively how to use it to obtain the effects they want, but the majority need to study the theory of colour.

Primary colours

The three primary colours are red, yellow and blue, and they are unique in that they cannot be produced by mixing any other colours. Although, in theory, any conceivable colour can be made by mixing together two or three of the primaries, in practice the impurities inherent in paint prevent the literal realization of this ideal. Not all yellows and blues make a true green: thus if the blue has a bias towards red (French ultramarine, for example) and the yellow has a hint of orange, the result will be nearer khaki than pure green. So choose a blue with a hint of yellow, such as Winsor or Prussian blue, and a pure yellow, and all will be well.

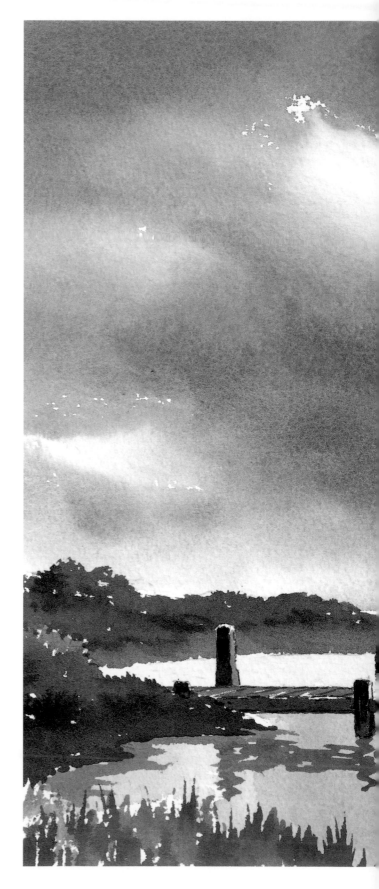

SEA INLET

It is possible to create a mood and atmosphere by the imaginative use of colour.

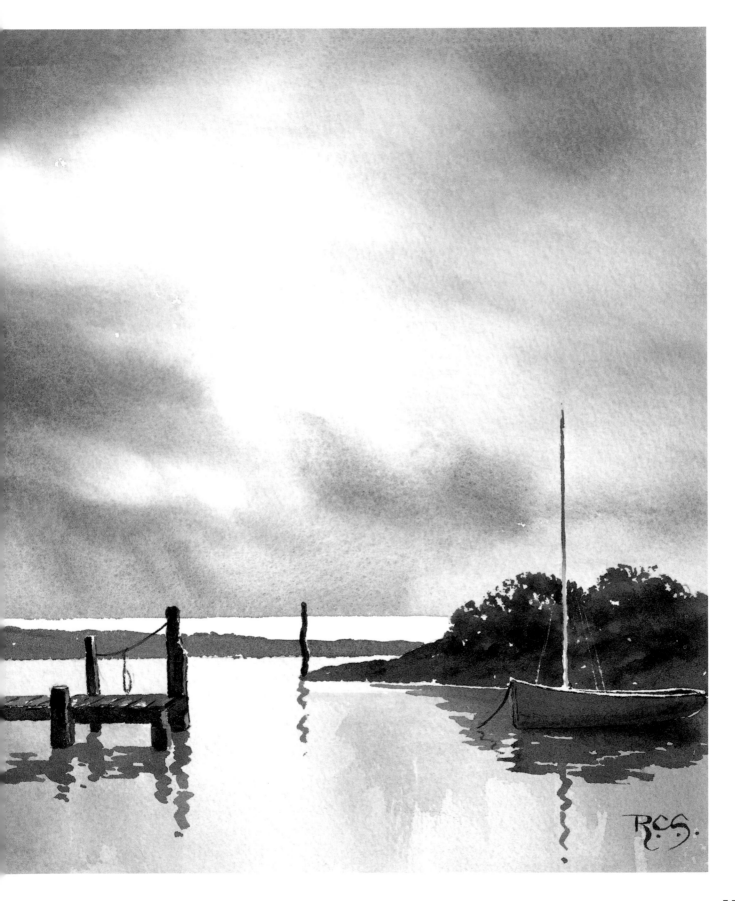

The classic example of complementary colours is the placement of a red figure against a green background.

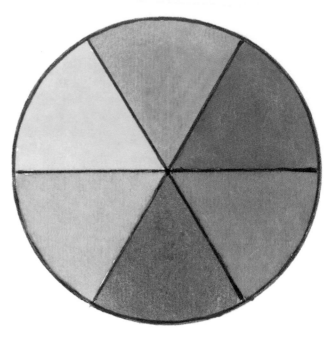

Primary and secondary colours on the colour wheel.

Secondary and complementary colours

Mixing together two primary colours produces the next group, the secondaries. These are orange (mixed from red and yellow), violet (mixed from red and blue) and green (mixed from yellow and blue). We now have the six basic colours of the simplest form of colour wheel. The colours placed exactly opposite each other on the wheel are known as complementary colours, or opposites. Thus red and green are opposites, yellow and violet are opposites, and so are orange and blue.

Placing two complementary colours side by side creates a telling contrast and a powerful visual impact. Because they are opposites, they have the effect of heightening the strength and brilliance of each other. Knowledge of complementary colours and their behaviour is a potent weapon in the armoury of artists and enables them to create tension and impact whenever these attributes may be required.

Tertiary colours

The third group of colours consists of the tertiaries, which are made by mixing the three primaries, or one primary and one secondary. If the three primaries are mixed in roughly equal proportions, the result is a dull brown or grey, but where one primary predominates, the result is very different, and a subtle or beautiful colour can result. Tertiaries are sometimes known as 'broken' colours. Mixing and experimenting with colours in this way is fun, and you will, in time, learn how to obtain the exact shade you need for your work.

Tertiary colours.

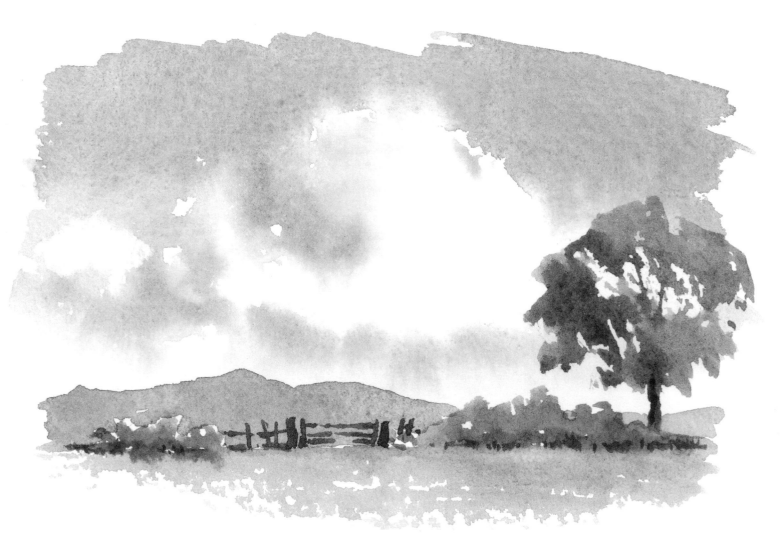

The warm foreground appears nearer than the receding, cool background.

Colour temperature

Knowledge of colour temperature and the ability to use it effectively are useful for promoting the feeling of recession and aerial perspective in landscape paintings. Some colours are warm, notably the red, orange and yellow family, for these are the colours of fire and flame. The cool colours are the blues and greys, the colours of shadows falling over snow and ice. In between are the great mass of intermediate colours.

From the painter's point of view, colour temperature is important for its relationship to distance. Warm colours appear to come forward and cool colours recede – a phenomenon you can confirm simply by examining any landscape: thus hills in the distance are blue or blue grey, while the foreground colours are much warmer. Even when the foreground is green – which is normally considered a middle temperature colour – it will tend towards yellow and so be a warm green, whereas a field in the distance will almost certainly be a bluey green, in other words a cool green.

Tone and tone value

The term 'tone' frequently causes confusion because, in common parlance and, indeed, in some dictionary definitions, it implies the tint or shade of a colour. In the context of art, however, it simply means the lightness or darkness of a colour – in watercolour terms, the strength or weakness of a colour wash – and the type or shade of colour does not enter into it. Tone, in this sense, is of the utmost importance to the artist, and you must develop your ability to judge the various tones of objects in the landscape, and to commit them accurately to paper. It often helps if you can make a quick preliminary tone sketch in monochrome so that you can assess and consider tone values without the added complication of colour.

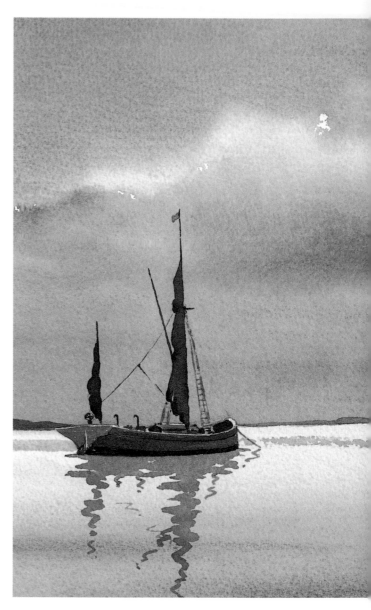

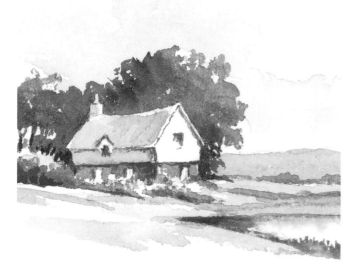

A preliminary tone sketch.

Handling tone values effectively is not simply a matter of accurate observation of the lights and darks, and there are occasions when you have to vary the tones. In certain weather conditions, for example, there are days when the atmosphere is entirely mist free and the distance appears just as clear as the foreground, with no perceptible difference either in tonal contrast or in tone itself. If you were to paint such a landscape literally, your painting would lack any feeling of recession and would look unreal and unconvincing. This is where artistic licence is justified and a little aerial perspective can be brought into play.

Watercolour is a delicate and subtle medium, not designed to equal the powerful colours and rich darks of oil paint. This does not mean that it has to be pale or wishy-washy, but simply that there are occasions when understatement is

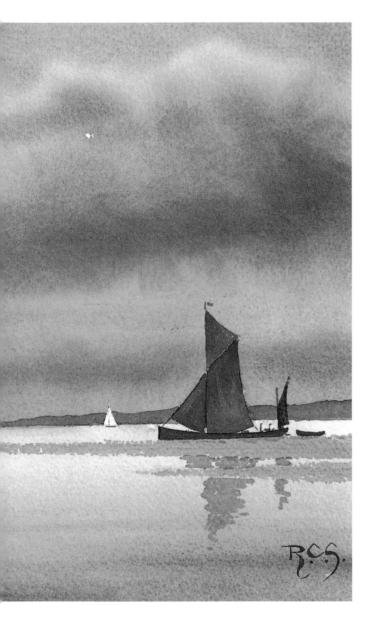

CALM ANCHORAGE
The soft, muted tones and colours of the clouds and sea are broken only by the contrast of a tiny, pure white sail in the distance.

necessary and when literal treatment of the colours and tones would push the medium beyond what it can effectively deliver, with consequent loss of freshness and transparency. Knowledge of the medium's limitations is the beginning of wisdom!

Practice exercise
MIXING GREENS

Most proprietary greens are too bright and contain too much blue for landscape painting. Well-kept lawns can be a fairly bright green (cadmium yellow with a touch of Winsor blue) but the meadow grass of a rural scene often contains a hint of brown, and raw sienna should be substituted for cadmium yellow. Trees and hedges often contain warm tints, particularly as autumn approaches, and a little added burnt sienna may be used. In the watercolour sketch below I used raw and burnt sienna and Winsor blue – why not experiment with these colours?

Materials
Sheet of watercolour paper
1-in (2.5-cm) flat brush
No 8 round brush
Paint: raw sienna, Winsor blue, burnt sienna

1 Apply a wash of raw sienna with a touch of Winsor blue for the meadow grass.

2 Prepare a deeper wash of the same two colours, plus a little burnt sienna, for the hedge and tree foliage.

3 Strong Winsor blue and burnt sienna, added wet-in-wet, indicate shadow.

Features of the landscape

Having considered watercolour techniques in some detail, we now come to the exciting stage of putting them into practice, and begin to tackle the various features of the landscape. Some can be captured by using just one technique, others will require two or more, but you must resolve at all costs to use these new-found skills and never to resort to any bad old habits simply for the sake of accuracy. This often means making a fundamental change in your approach to painting, so that you are no longer concerned just with producing exact and precise images of the scenes, and instead aim to reflect them in correctly applied washes. This approach may well lead to a bolder, looser style of painting – a goal to which many watercolourists aspire – but it does not preclude the more detailed style, which is perfectly acceptable provided the canons of sound technique are observed.

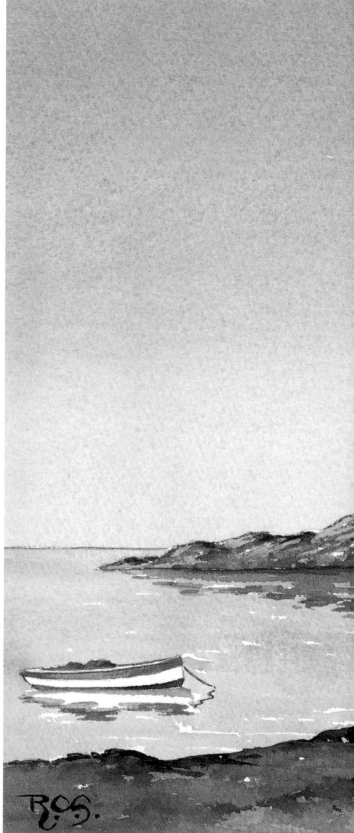

CORSICAN COVE

The gentle light from a cloudless sky brings out the warm colours of the buildings that are reflected in the water below.

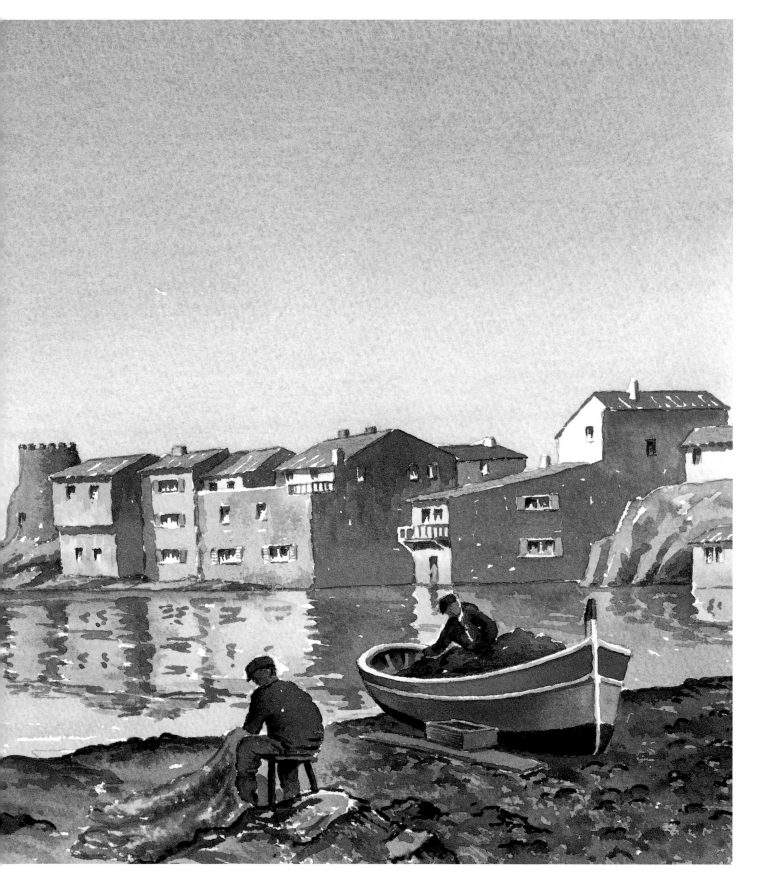

Skies

Most painters begin by putting in the sky because it is normally a pale area, and it is good practice to work from light to dark in watercolour. Another good reason is that the way the sky turns out influences every other part of the painting, so it makes sense to establish this first.

Clear skies

A clear sky is unlikely to be a uniform blue all over, but probably becomes paler and warmer as it approaches the horizon. This immediately suggests a variegated wash, the result of one colour smoothly blending into another.

First, prepare generous liquid washes of the appropriate colours: the blue of the upper sky could be French ultramarine with just a touch of light red to calm it a little, and the lower sky could be raw sienna, also with a little light red to warm it. Then, using the technique of the variegated wash, apply the blue in broad, horizontal brushstrokes with a large brush, and about a third of the way down the paper, dip the brush into the pool of the warmer colour to make a smooth transition from the first colour to the second. If there is still an unwanted trace of the first colour at the bottom of the variegated wash, simply reverse the order and apply the pale, warm colour first and finish with the stronger cool colour.

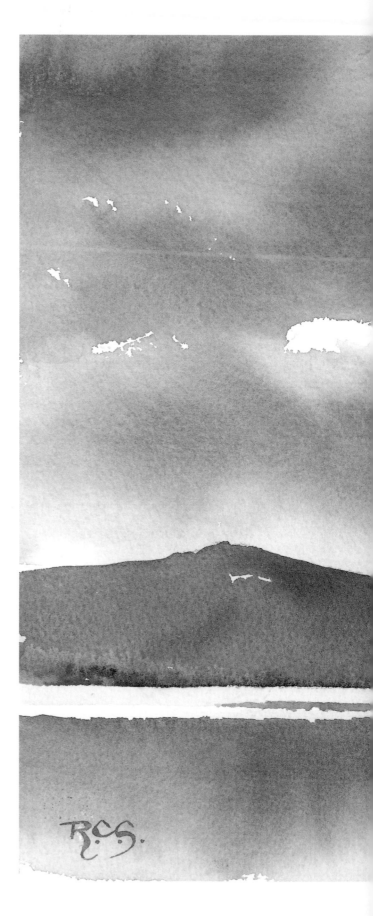

BREAK IN THE CLOUDS

In addition to the effect of bright light shining out of a dark, moody sky, and falling on to the lake surface, the grey and white buildings add a sense of drama.

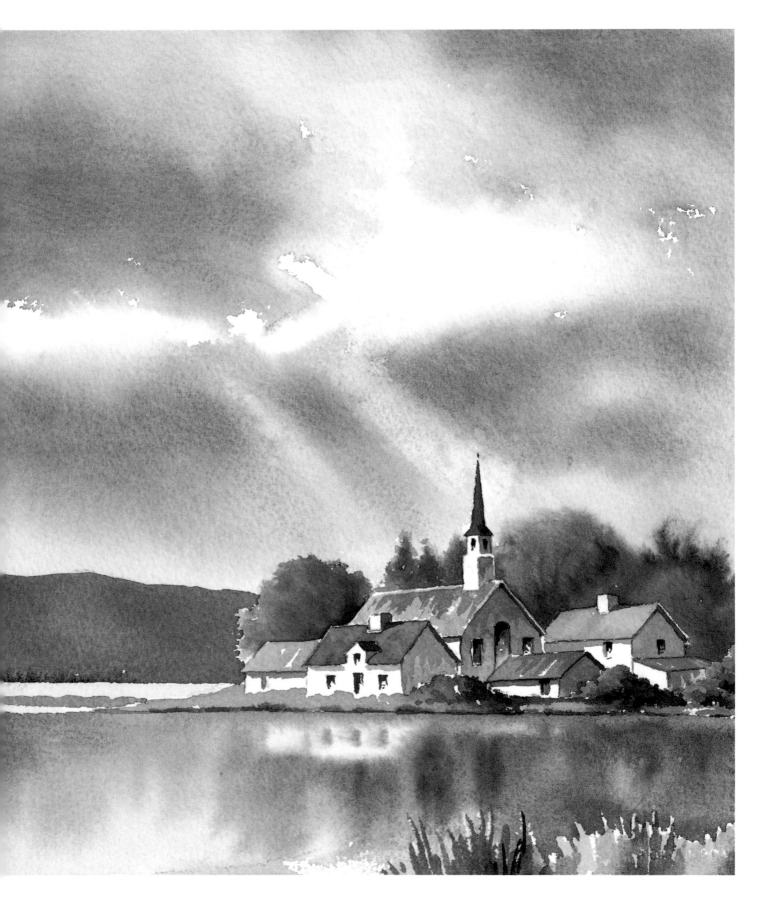

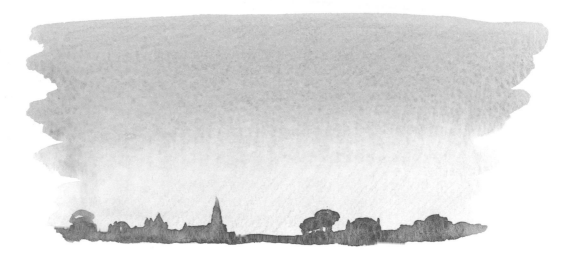

This clear sky is produced by a variegated wash.

Here there is no trace of blue in the lower sky.

Colour depends to a large extent on climate, and you should always distinguish between the intense blue of Mediterranean, Californian or tropical skies, for which French ultramarine is perfect, and the less intense blues of northern skies, which may require cobalt, Winsor blue or something between the two. In watercolour pure blue can often look too harsh and needs taming, perhaps with a touch of light red.

Cloudy skies

Clear blue skies are a little lacking in interest from the painter's point of view, so we turn our attention to clouds. Perhaps the simplest way to indicate them is to use wet-in-wet, and drop in colour, such as a warm grey, into a previously applied variegated wash (remembering that the second wash must be less liquid than the first). A good mixture for the grey would be French ultramarine and light red. If you want to introduce a little light into the clouds, remove some pigment from the background wash while it is still wet and drop in a little pale raw sienna. The level layers of stratus cloud formations can

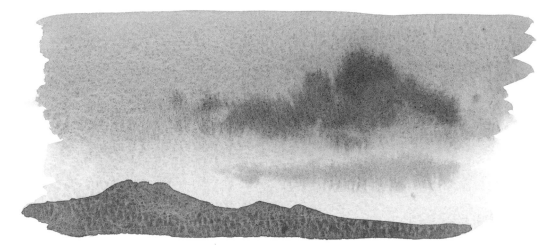

Deep-toned grey clouds added wet-in-wet.

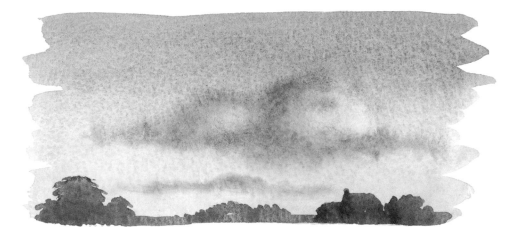

Wet-in-wet clouds with sunlit areas.

be either hard- or soft-edged, according to the weather conditions. They are best rendered with broad, horizontal strokes of a large brush, on a dry surface for hard edges, or a wet surface for soft results. If they are to be paler than the blue of the sky, apply a suitably pale wash first, before the blue of the sky.

In my view the most paintable skies of all are those containing billowing cumulus clouds, with their level bases and their high, domed crests. They are so full of life, movement and shape that you need to give them plenty of space to do them justice, which, in practice,

means having a low horizon. They often recede fairly regularly into the distance and so must be painted with due regard to perspective: not only do the clouds themselves decrease in size as they recede, but the spaces between their level bases also diminish.

There is normally an appreciable amount of clear sky behind cumulus cloud formations, and this should be painted as a variegated wash, with the blue becoming softer and warmer as it approaches the horizon; it may be interrupted by more cloud. The strong blue at the top makes an effective background to the clouds

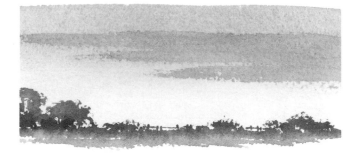

Hard-edged stratus clouds.

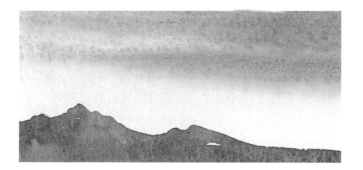

Soft-edged stratus clouds.

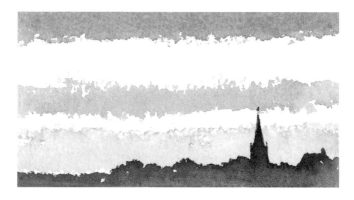

A pale layer of stratus cloud.

SEE ALSO:
- Variegated washes, page 38
- Wet-in-wet, page 48

To start with, prepare four washes: the palest being raw sienna for the sunlit areas of the clouds; a mixture of French ultramarine and light red for the cloud shadows; then French ultramarine and just a touch of light red for the blue of the sky; and raw sienna and a little light red for the lower sky.

Make a careful note of the direction of light from the sun, then apply the first wash to areas of sunlit cloud, but let the white of the paper stand for others, especially those facing the light source. Drop in the second wash for the grey cloud shadows, wet-in-wet, on the undersides of the clouds and on the sides away from the light. Apply the third wash to give shape to the tops of the clouds and retain some hard edges. Finally add the fourth wash for the area of warm-coloured sky just above the horizon and, where necessary, run it softly into the area of blue sky. Work fairly briskly because it is important to get everything done before the drying process begins – if drying overtakes you, the first casualties will be freshness and clarity.

and helps to indicate their billowing forms. The clouds themselves may have pale sunlit areas and soft grey shadows.

You can paint such skies using the wet-in-wet technique, dropping the blues and greys into a wet underwash, and achieving a soft-edged effect. Or you can use the alternative method described here, which produces both hard and soft edges on the clouds.

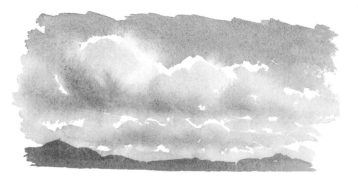

A wet-in-wet impression of cumulus clouds.

I rarely paint cirrus clouds, those fluffy shreds of frozen water vapour, because their tiny, repetitive patterns do not lend themselves to bold watercolour techniques and any other treatment would involve excessively precise work. The only answer has to be some drastic simplification of their intricate forms.

Finally there is the nimbus cloud, or storm cloud, which tends to be ragged and shapeless, but can often provide a telling backdrop to dramatic mountain or desolate moorland scenes. Their powerfully contrasting tones can often be used to good effect to create strong tonal contrasts.

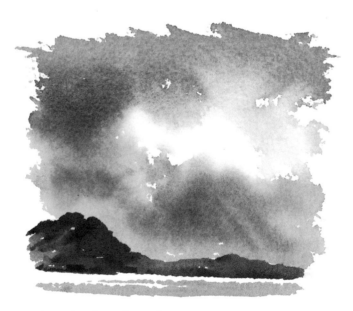

Nimbus clouds and tonal contrasts.

TIP
John Constable recommended painting a sky study every day – perhaps a counsel of perfection in these busy times – but practice and more practice is the way forward.

Practice exercise
PAINTING CLOUDS

Just like everything else in the landscape, cloud formations often have to be simplified to make them amenable to effective watercolour treatment. The sketch below is of a simple cumulus cloud formation, and I applied the washes quickly, allowing some soft merging but retaining some hard edges. Now try a quick cloud study for yourself.

Materials
Sheet of watercolour paper
1-in (2.5-cm) flat brush
Paints: raw sienna, French ultramarine, light red

1 Apply a wash of water containing just a touch of raw sienna for the sunlit clouds. Leave a few areas of untouched paper for the highlights.

2 Add the second wash for the cloud shadows, on the sides away from the light source and on the undersides. Allow these two washes to blend.

3 Add the third wash for the blue of the sky, allowing some blending but retaining some hard edges.

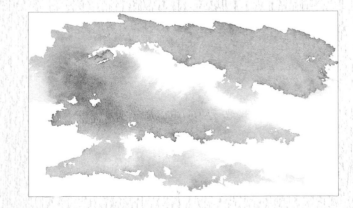

Light

Light is an all-important element of landscape painting and you should always be sensitive to its effects – sometimes subtle, and sometimes dramatic, but never less than fascinating. When correctly used, watercolour is capable of capturing these wonderful effects, and it is up to you first to appreciate them, then to study them, and finally to reflect them in your work.

Light direction and quality

The first thing to do is to make a mental note of the direction of the light. If you expect to take an appreciable time to complete a painting, it is wise to sketch in the shadows early on, so as not to end up with shadows at a variety of angles due to the movement of the sun.

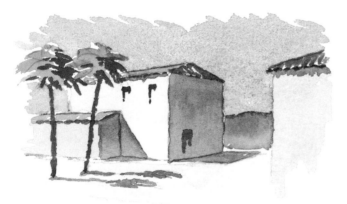

Midday shadows are often deep and hard-edged.

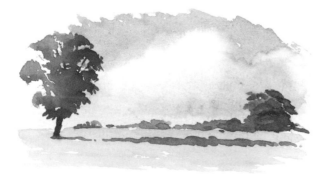

Evening shadows are more gentle and longer than those cast at midday.

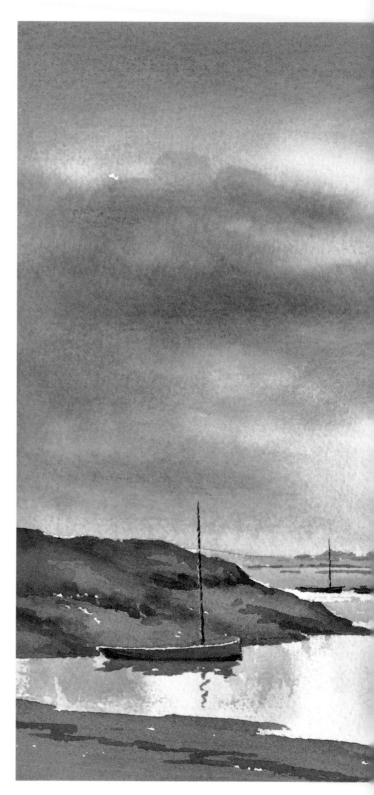

MARSHLAND VISTA
The low-lying or flat countryside of marsh areas is perfect for examining and painting the effects of light on the landscape.

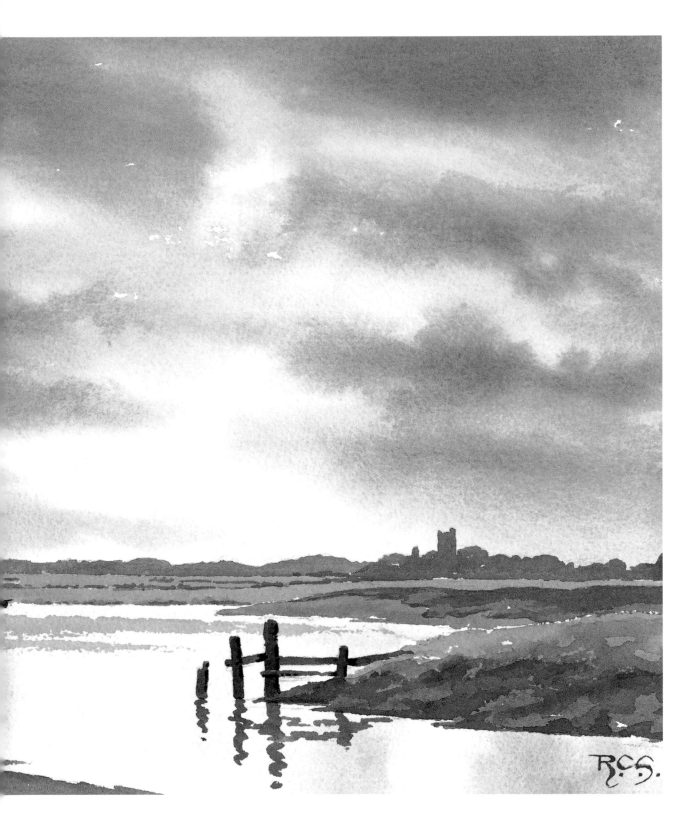

The quality of light can vary greatly according to the time of day, the season and the region of the world where the scene is set. In summer and autumn the light can be warm or even golden, whereas in spring it tends to be cool, and in winter often positively cold.

The light from the midday sun is usually strong and casts short, hard shadows. At dawn and dusk the light is softer and warmer, and the shadows are far longer.

It is also worth taking note of the effects of climate and of variations in the quality and colour of the light in tropical, Mediterranean and temperate regions.

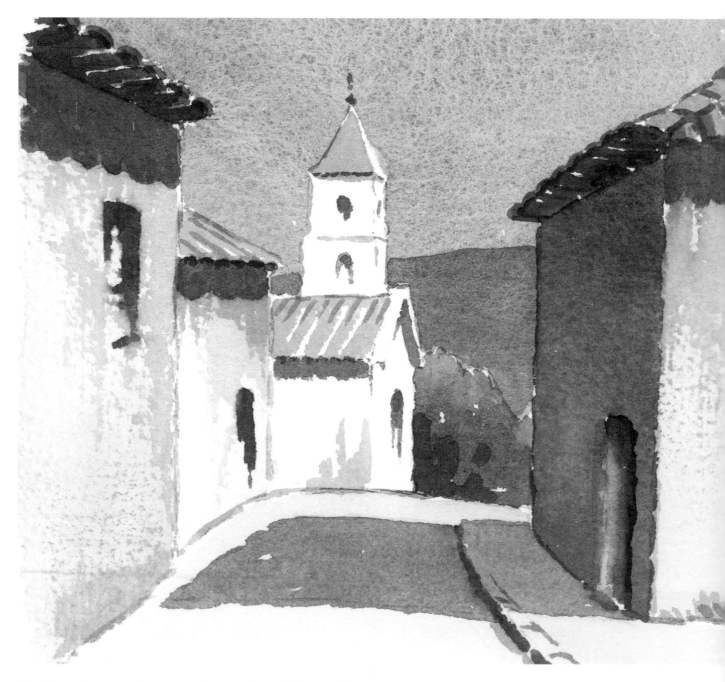

Shadows often contain warm colours reflected from sunlit areas.

SEE ALSO:
- Palette of colours, page 16
- Colour temperature, page 57
- Tone and tone value, page 58

Weather effects

The weather naturally plays an important part in determining the quality of the light. In misty and some cloudy conditions it is soft and diffuse; at other times broken clouds give rise to strong tonal contrasts of sunlight and shadow over the countryside, which you can exploit to give tension and drama to your landscapes.

Take note of how lateral light can catch the tops of objects in the landscape and turn them into highlights and points of focus, and be aware that shadows are not just a flat grey but often contain rich colours and warm, reflected light. If you are sensitive to these and other subtle effects, and reflect them in your painting, your work can take on a new dimension.

TIP

In temperate lands, use pale raw sienna, sometimes warmed with a little light red, for warm light. In sunnier climes the brighter combinations of cadmium red, orange and yellow are suitable. French ultramarine, with a little raw sienna, cobalt blue and Winsor blue, sometimes in combination, are suitable for northern skies, while French ultramarine alone is just right for the hot, intense blue of the Mediterranean and tropical lands.

Practice exercise
PAINTING CAST SHADOWS

Beginners often fail to observe the shape of shadows as they fall across uneven ground, and proceed to paint them as though the surface was completely flat. Capturing the true shape of such shadows helps to describe the form of the ground over which they fall and makes for a far more convincing painting. The shadows in the sketch below help to indicate the banks and the camber of the farm track. Why not try a similar watercolour sketch for yourself?

Materials
Sheet of watercolour paper
1-in (2.5-cm) flat brush
No 10 round brush
Paints: raw umber, raw sienna, Winsor blue, Payne's grey

1 Sketch in the shape of the track, its banks, the foreground grass and the trees.

2 Use pale raw umber for the track, raw sienna with a little Winsor blue for the foreground grass, and a deeper mixture of raw sienna, burnt sienna and Winsor blue for the tree foliage.

3 When everything has dried, use Payne's grey for the cast shadows, ensuring that it indicates the shape of the ground over which it falls.

Foregrounds and backgrounds

The part of the landscape that sets most painters the toughest problem is undoubtedly the foreground: everything is so close that you cannot ignore its details, and yet so many foregrounds contain just the sort of complexity that can lead to terminal over-elaboration and overpainting! Any attempt to paint every blade of grass or every pebble is doomed to failure and quickly leads to a surfeit of tedious detail and repetition; what is more, it is likely to attract too much attention to itself and so overshadow the intended centre of interest. The problem is what to do once you have firmly decided to avoid becoming involved in painstakingly including every last detail.

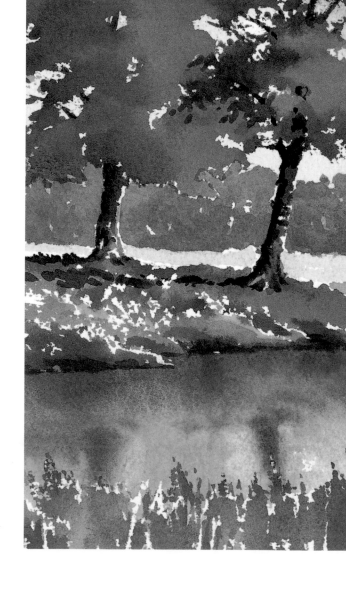

BEND IN THE RIVER
Using a stretch of water as the foreground is an effective way of leading the viewer's eye into the picture.

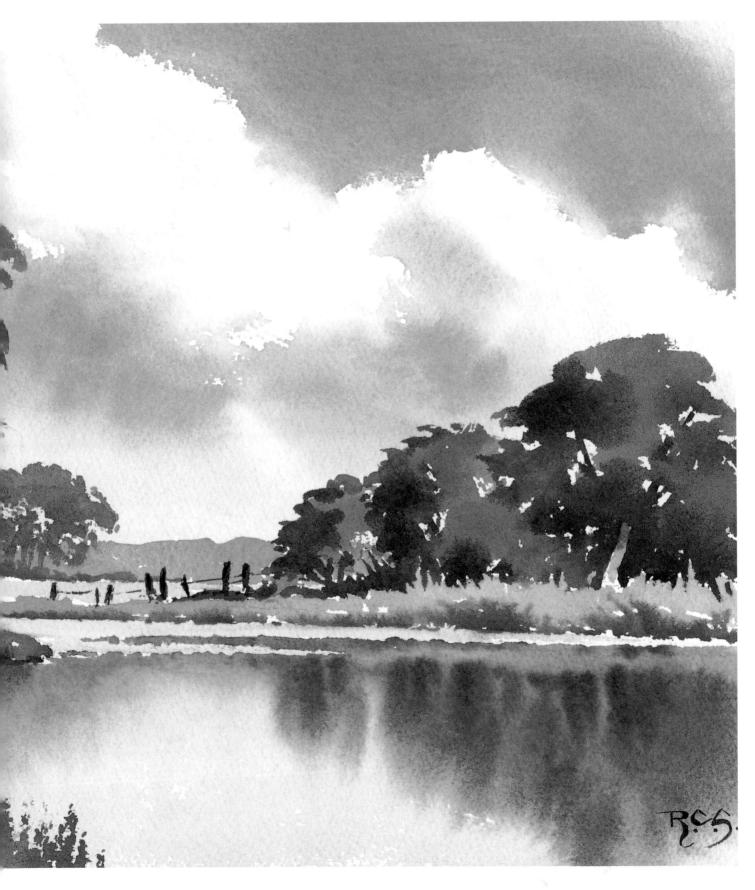

Using broken washes

Clearly a flat wash or even a variegated wash is bound to be too bland and featureless to suggest the character of the foreground. The only practical alternative is the broken wash. If you have practised this technique since making its acquaintance earlier in the book, you may well be able to lay down a respectable broken wash which indicates some form of foreground texture. As described on page 46, the degree of liquidity of the prepared wash and the amount taken up by the brush are both crucial, and sound judgement on this technique can only come with experience and practice. If the wash is too liquid or the brush is too fully charged, even the little hollows receive pigments and you are left with a flat wash. If, on the other hand, it is insufficiently liquid, the result will lack clarity and freshness.

If the little white dots left in the paper appear too glaringly white, the application of a pale glazing wash of a suitable colour can put things right. It is, of course, safer to apply the pale wash first to avoid any danger of disturbing the broken wash. Practise doing this for yourself, using offcuts of watercolour paper or even the reverse side of paintings which have failed to come up to your expectations.

Even the most practised broken wash rarely tells the whole story, and there is usually more that needs to be done to it. First, you can vary the tone and/or the colour of the wash to produce what might be described as a broken graded wash or a broken variegated wash, which can help to capture variations in the different parts of the foreground.

A deeper mixture of the original wash, dropped in wet-in-wet, gives the grass and shingle more form.

Sometimes deeper-toned colour, dropped wet-in-wet into the broken wash, can also help, while added touches of detail, wet-over-dry, provide useful clues as to the nature of the foreground, which the eye subconsciously applies to the remainder of the broken wash.

Broken washes suggest rough foreground grass and shingle.

A second wash is applied wet-over-dry, to create texture.

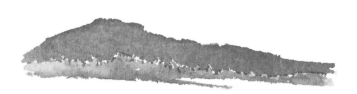

The far distance shown as a flat wash of blue-grey.

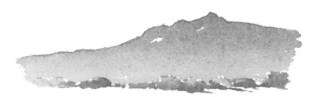

The blue-grey merges into a hint of green.

Aerial perspective

The atmosphere is never completely clear, as water vapour, smoke and dust particles all play their part in reducing clarity. The amount of water vapour is crucial, and in general terms the more there is, the mistier the conditions. It follows that the more atmosphere there is between the viewer and some object in the landscape, the greater this effect, known as aerial perspective. The main effects of aerial perspective are:

■ Tone decreases with distance so that the foreground is relatively deep toned, the middle distance paler and the distance paler still.

■ Tonal contrast also decreases with distance, with big differences between lights and darks in the foreground and little or none evident in the far distance.

■ Foreground colours tend to be warm and distant colours cool.

Choosing washes

A common mistake is to omit any link between the cool colours of the distance and the warm colours of the foreground, as the effects of aerial perspective are gradual rather than abrupt. One of the ways to overcome this fault is to treat the distant scene as a variegated wash rather than a flat wash.

In some conditions there is a degree of tonal contrast in the distant scene, and woods and hedges may well appear slightly deeper-toned than the surrounding fields. This effect can be captured by adding a second wash of the same colour, wet-over-dry. You can indicate shadows on distant hills and mountains by applying the second wash wet-in-wet.

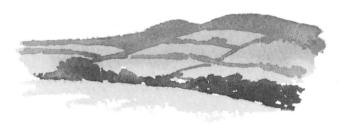

The trees and hedges on a distant hill are suggested by a wet-over-dry application of the original wash.

Soft shadows on distant hills are suggested by applying a deeper-toned wash of the same colour wet-in-wet.

SEE ALSO:
■ Glazing washes, page 39
■ Broken washes, page 44
■ Wet-in-wet, page 48
■ Aerial perspective, page 51

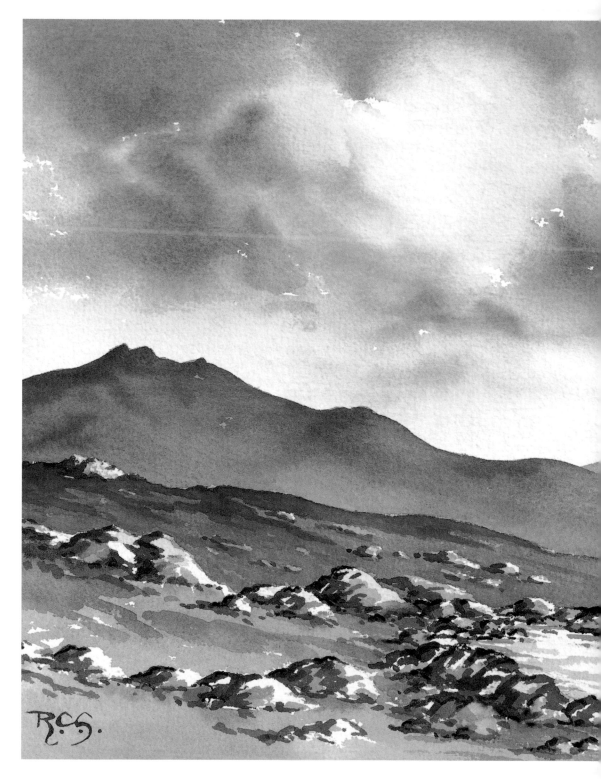

HIGHLAND STREAM
*The texture of the rocks and stream in
the foreground contrasts with the smooth
graded and variegated washes used to
paint the distant mountains.*

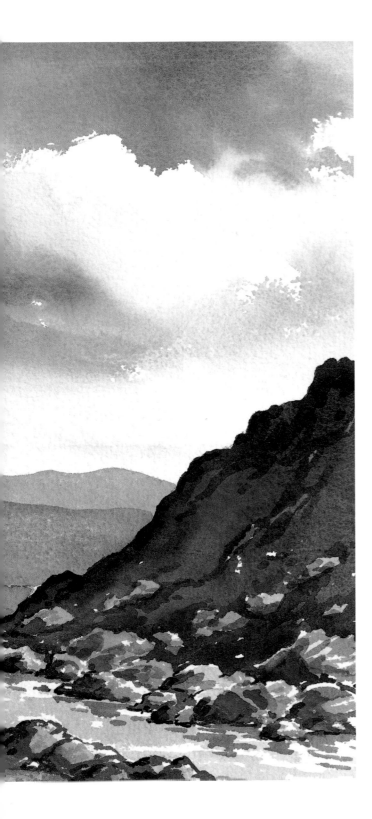

Practice exercise
CAPTURING AERIAL PERSPECTIVE

In the sketch below, the foreground is more strongly painted than the background; the difference between lights and darks (the tonal contrast) is much greater in the foreground than in the middle distance, with tonal contrast disappearing altogether in the far distance. The colours of the foreground are generally warm, and this warmth gradually decreases into the distance, where you will see that the colours are wholly cool. Try for yourself a watercolour sketch showing these effects of aerial perspective.

Materials
Sheet of watercolour paper
1-in (2.5-cm) flat brush
No 8 round brush
Paints: French ultramarine, light red, raw sienna, Winsor blue, burnt sienna

1 Sketch in lightly a simple landscape scene.

2 When the sky washes have dried, paint in the distant hills in a flat wash of French ultramarine and light red.

3 The colours of the grass and foreground foliage are much warmer than those in the distance. Use raw sienna with a touch of Winsor blue for the grass, and various combinations of raw and burnt sienna and Winsor blue for the foliage.

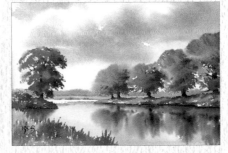

Trees and foliage

Trees are such a vital part of the rural scene that you must make a determined effort to learn how to paint them effectively and economically. To start with shape, trees of different species have characteristic forms which require careful observation. Study the structure of bare winter trees, noting how the branches taper, how they join the trunk and so on, as this helps when painting them in full leaf.

Attempting to paint every twig and leaf is not the right approach and is bound to lead to an overworked and over-elaborate result. The mass of leafy detail can present a problem, and the answer lies in trying to see the foliage in the mass while ignoring the detail. If you observe your subject carefully through half-closed eyes, detail dissolves into areas of varying tone and colour – and it is these that you should aim to paint.

To capture the broken edges of foliage without resorting to numerous dabs of paint with the point of a small brush, use the side rather than the point of the brush so that it makes contact with the little hills in the surface of the paper and misses the little valleys. A Rough surface makes this method considerably easier and more effective – it is simply an extension of the broken-wash technique.

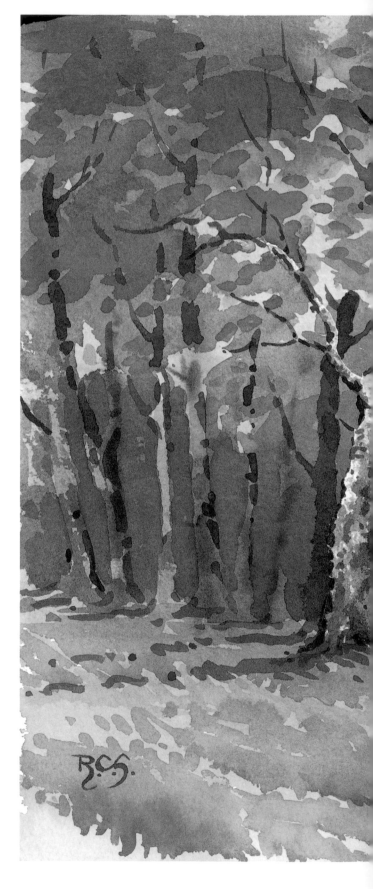

WOODLAND SUNSHINE

When the thick leaves of trees form a canopy overhead, even strong sunlight can be muted and can produce a subtle dappled effect rather than a bright glare.

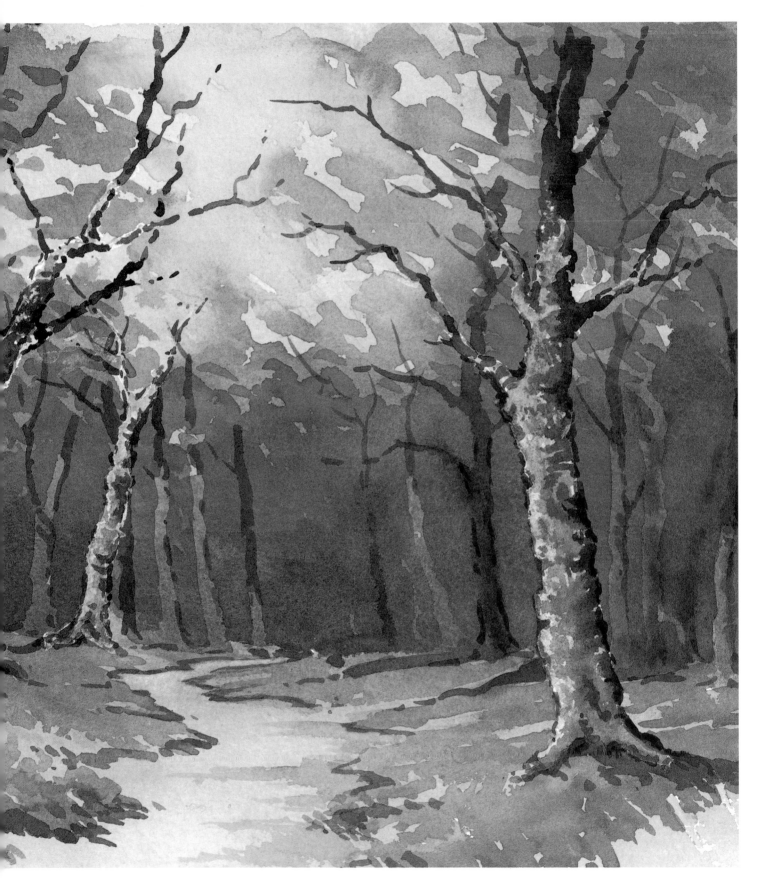

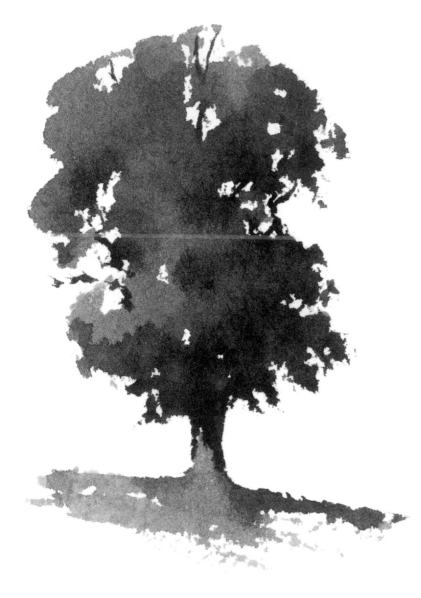

A late summer tree with full foliage.

Tree colours

Do not be content to use made-up greens, which are often too harsh and artificial for tree foliage, but mix your own. Even in high summer there are colours other than green, and these should be exploited to the full, otherwise your summer landscape may end up looking too overwhelmingly green. Note the colours and tones of the shadowed areas; you may find unexpected colours here, so do not simply use a stronger version of your first wash. Study the

colours of tree trunks as well as of foliage; they are rarely the browns they are often painted, but more often greys, with green overtones nearer the ground.

For the late summer tree shown on the left, I prepared three washes: raw sienna plus a little Winsor blue, just burnt sienna, and, for the shadowed areas of foliage, a stronger mix of raw sienna, burnt sienna and Payne's grey. Using the side of a No 10 brush charged with the first wash, I put in the main mass of foliage, keeping in mind the overall shape of the tree and the form of its broken outline.

While this was still wet I dropped in a little of the burnt sienna wash here and there to hint at the onset of autumn, and finally added the stronger third wash for the shadows and shaded trunk. A quick flick of a brush charged with a diluted version of the first (green) wash served for the grass, and a touch of the third, deeper wash for the tree shadow.

As your ability progresses you can add the areas of branch and trunk which are seen in the 'sky holes' between the leaves, and similar techniques and colours can be used to paint bushes and hedgerows.

Sections of branch are visible through 'sky holes'.

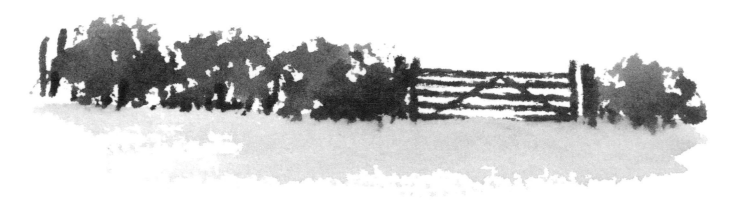

A bold impression of a hedgerow.

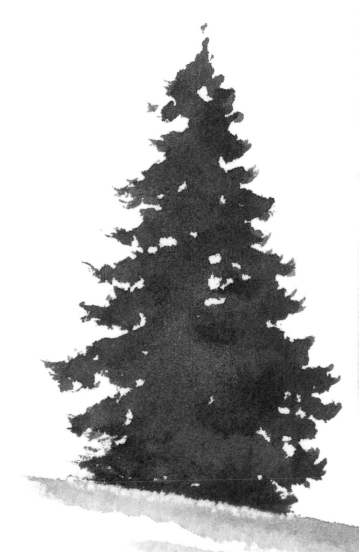

Conifers and evergreens

Conifers present a slightly different challenge. They are usually cooler in colour, and with a more erect and regular form, but the method of painting them is much the same. It is an error to make their outline too regular and symmetrical.

TIP

Inexperienced painters often make their trees and grassy fields much the same tone, with the result that their work lacks enough tonal contrast. It is a matter of observation that trees are deeper in tone than the fields around them, due partly to their form and shape, and partly to the fact that the average leaf is a deeper colour than a blade of grass. Maintaining this difference helps the tonal structure of your landscape work.

Conifers have distinctive, erect shapes.

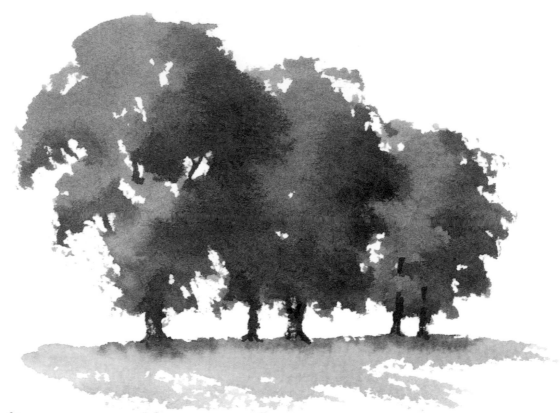

A group of trees.

Groups and masses

Painting individual trees is one challenge, but painting them in groups is quite another. It is not just a matter of using the same techniques and placing the trees side by side – you have to give some impression of grouping, overlapping and merging, so the use of soft edges is a very helpful technique.

Aerial perspective

Remember to pay due attention to the effects of aerial perspective when painting woodland subjects. You cannot normally see far enough into a summer wood for this to register appreciably, but winter woodlands and copses are another matter. Here the trunks not only decrease in size as they recede, but become ever paler and cooler in colour as well.

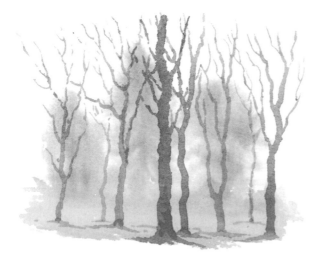

A winter woodland scene shows the effect of aerial perspective on the background.

THE OLD TREE

The strong handling of the shape and texture of the foreground tree contrasts with the softer treatment of the more distant trees.

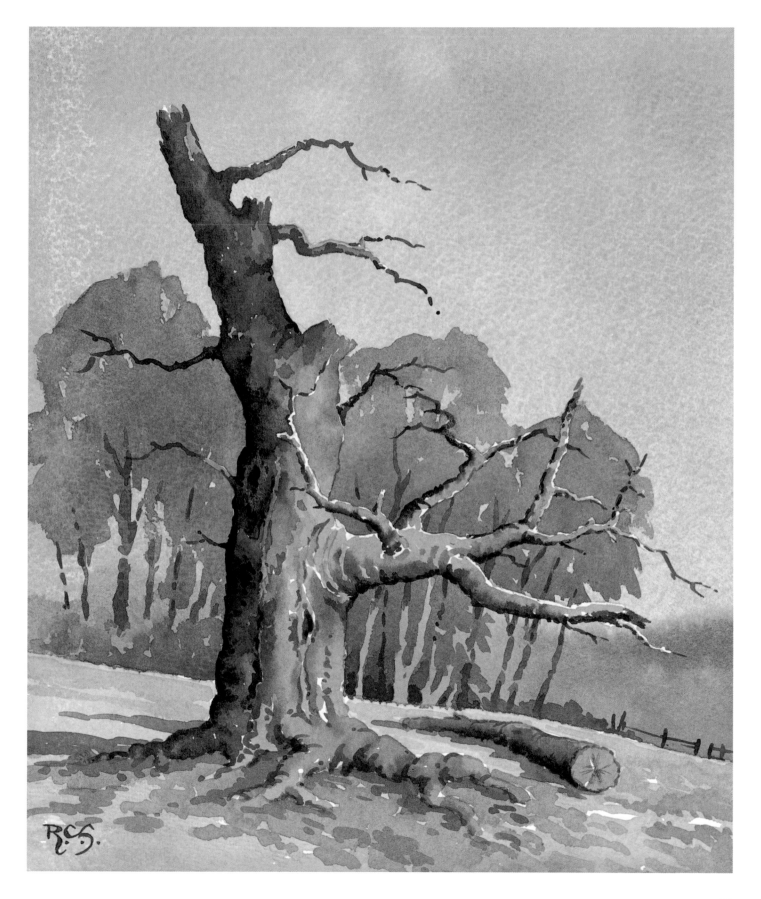

Distant trees and hedges.

Drybrush work captures the effect of rough-textured bark.

In the far distance the effect of aerial perspective is often such that tonal contrast disappears altogether and the pattern of far woods and hedgerows is lost to view. Use a flat wash of a suitable grey, perhaps French ultramarine and a touch of light red, in order to convey this effect.

In other conditions, where some tonal contrast remains, any details can be suggested by an additional wash of the original mixture, applied wet-over-dry. And in order to suggest the rough texture of bark, experiment with using a little drybrush work over the base wash of the trunk.

SEE ALSO:

- Capturing texture, page 42
- Drybrush, page 47
- Wet-in-wet, page 48
- Aerial perspective, page 51
- Colour and tone, page 54

TIP

The mass of twigs in bare trees needs much simplification and can sometimes be expressed by a wash which is a mixture of the local colour of the twigs and of the sky behind them. The tapering ends of the branches merge into this wash to produce a simple but convincing image. Rowland Hilder was a master at painting winter trees in this manner, and his highly individual work is worth studying.

Practice exercise
PAINTING TREES ECONOMICALLY

Trees are such an important constituent of the landscape that it is vital to develop techniques for painting them effectively without resorting to excessive detail. I made the quick impression below, making no attempt to paint every leaf. It is all too easy, when concentrating on the broken outline of the foliage, to overlook the overall shape of the tree – both have to be constantly borne in mind. Why not practise a few watercolour sketches of trees yourself?

Materials
Sheet of watercolour paper
No 10 and No 6 round brushes
Paints: raw sienna, Winsor blue, burnt sienna, Payne's grey

1 Prepare a wash of raw sienna plus a little Winsor blue for the sunlit foliage, and one of raw sienna, burnt sienna and Payne's grey for the foliage in shadow.

2 Apply the first wash, using the side of the brush to obtain a broken outline.

3 Drop in the second wash wet-in-wet, for the shadows on the side of the tree away from the light source and for the undersides of the branches. Also use this wash to suggest a few branches glimpsed through the 'sky holes'.

Buildings

'Landscape painting' usually conjures up visions of unspoilt countryside with hills and valleys, trees and fields, rivers and lakes, and tends to ignore the existence of buildings. However, the landscape is not exclusively the work of nature, and man's influence upon his environment must be recognized. The pattern of fields, hedgerows and winding lanes is a significant part of the rural scene, and farms and villages are equally important. This book is concerned mainly with buildings as part of the landscape rather than as subjects in their own right, but it is still necessary to spend time and thought on their treatment, so as to make the most of their role in the landscape.

Composition

The first consideration is composition. If, for example, farm buildings are strung out in a straight line, you may need to shift your position so that they may be viewed from a different angle, forming a more attractive and cohesive group. If the light is shining directly on them, they may look somewhat flat, and it pays to wait until the sun has moved so that a lateral light will cast shadows and give them a more three-dimensional appearance. Do not hesitate to make changes if needs be – the creation of a well-balanced and satisfying painting always takes precedence over accuracy and precision.

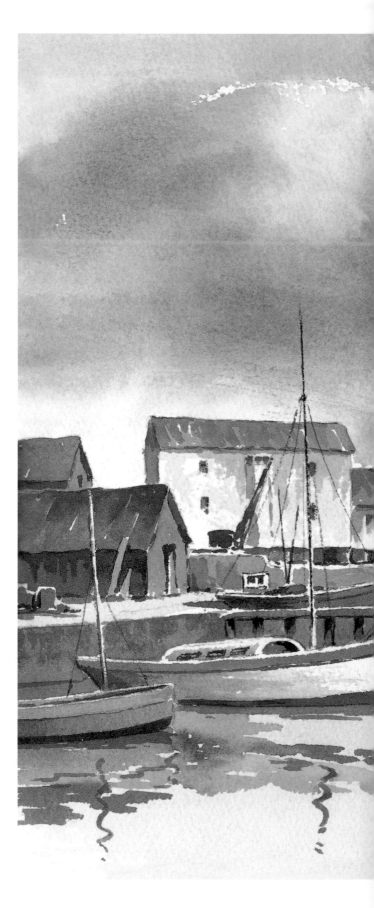

THE TIDE MILL
The distinctive shapes of the buildings provide a vertical counterpoint to the more horizontal shapes of the clouds, jetty and boats.

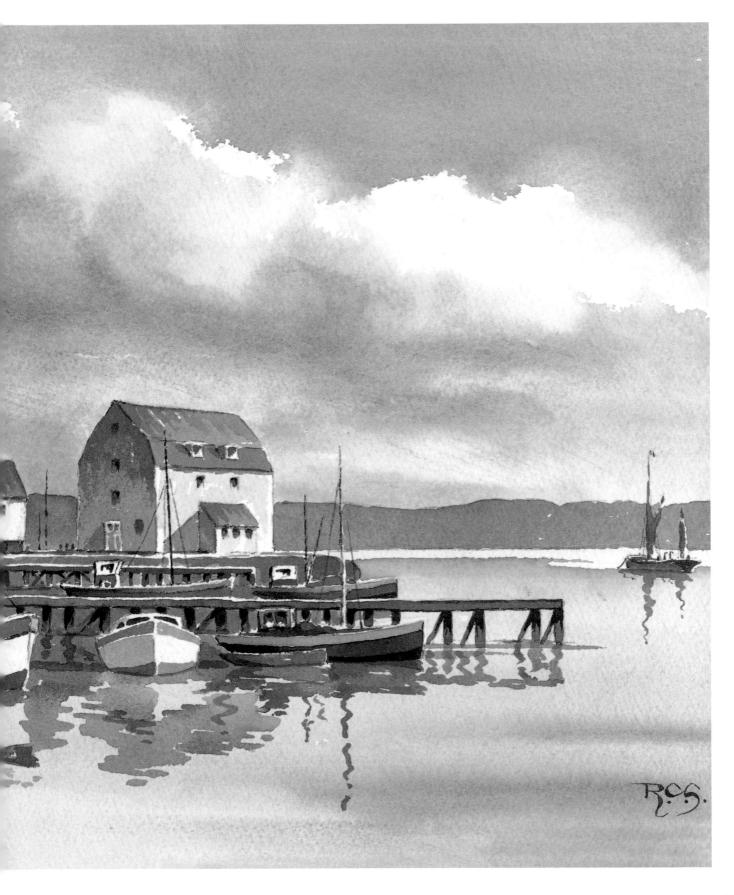

Textures

If buildings are in the middle distance, you do not have to worry about the texture of brick or stone masonry, and flat washes can do all that is necessary. If they are closer at hand, some indication of the type of material used in their construction is required. This should not involve the painstaking painting of every brick or stone; all that is needed is the painting in of some detail of a small section of the masonry or a few random blocks of stone, and the viewer's imagination can fill in the rest. What is more important is the indication of weathering and of local variations in colour or tone, achieved by applying variegated washes, which give your work character.

These middle-distance buildings are painted in flat washes.

Brickwork showing some weathering.

Stonework with local colour variations.

88

Light and shadows

The effects of reflected light in shadows are of particular relevance to buildings. The colours of cast shadows are also important but are all too often indicated simply by a deeper shade of the colour already used – a treatment which is rarely entirely satisfactory. Study shadows closely so that you can identify a variety of colours in addition to the local colour of the building. Light is also reflected from nearer objects: for example, imagine a narrow road, perhaps in a Mediterranean village, with colour-washed buildings on either side; one side of the road is in blazing sunlight, the other in deep shadow. The warmth of the sunlit buildings is likely to be reflected in the cool shadows of the buildings opposite to produce a warm glow.

Warm reflected light is captured by a variegated wash of both warm and cool colour.

SEE ALSO:
- Flat washes, page 30
- Variegated washes, page 38
- Aerial perspective, page 51
- Colour and tone, page 54

Windows and details

It is worthwhile studying such features as windows with some care, making a mental note of any variations, to protect yourself from the all-too-common error of making them all look exactly the same. Some will have curtains, others will not, some will be open, some closed, some glass panes will reflect light, others will not. This does not mean that the windows must be very carefully and meticulously painted, for these differences are sufficient to provide variety even in the loosest treatment.

Look for the detail to provide variety when painting otherwise identical windows.

Buildings in the distance

In the far distance, buildings are subject to the effects of aerial perspective. Their warm colours are replaced by cool blues and greys, also tonal contrasts decrease – often to the point of disappearing altogether – and they may well merge into adjacent areas of woodland.

Distant buildings with the effect of aerial perspective.

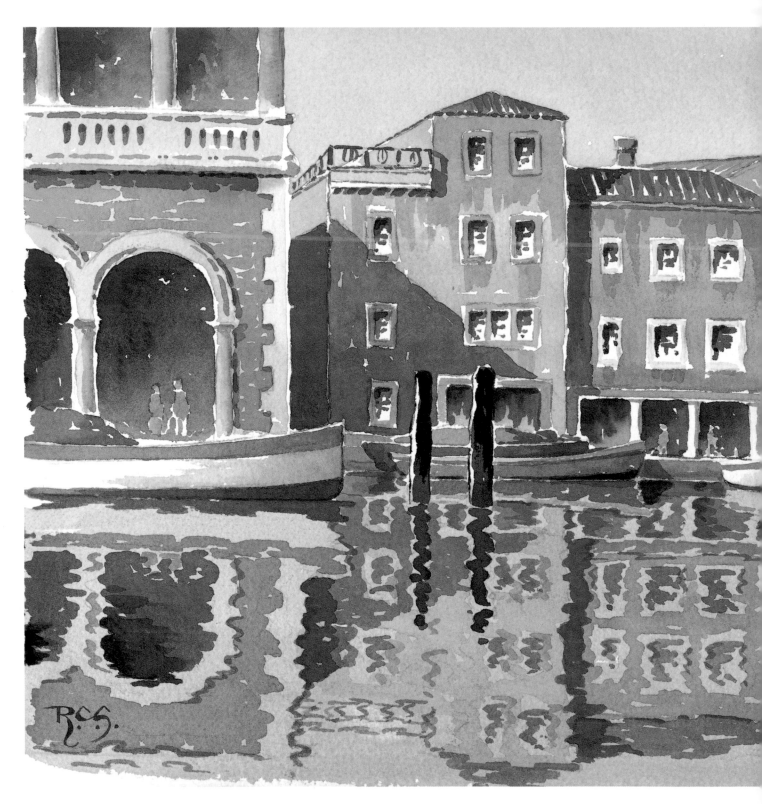

THE FISH MARKET, VENICE

*The ripples in the canal give a greenish tinge to the
reflections of the buildings. The lateral shadows give
the buildings greater interest and variety.*

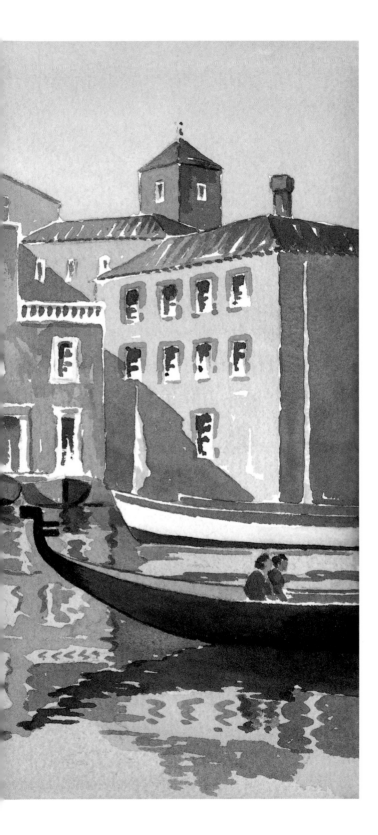

Practice exercise
FARM BUILDINGS

Buildings often form only a relatively small part of the rural scene and they are best indicated economically rather than painted in full detail. The sketch below suggests farm buildings among a stand of sheltering trees. Why not try your hand at something similar?

Materials
Sheet of watercolour paper
1-in (2.5-cm) flat brush
No 8 round brush
Paints: raw sienna, burnt sienna, Winsor blue, light red, French ultramarine

1 Sketch in lightly a few overlapping buildings and some surrounding trees.

2 Prepare several washes for the farm buildings, trees and fields. I used burnt sienna for the brickwork, raw and burnt sienna and Winsor blue for the trees, raw sienna and a little Winsor blue for the fields, light red for the ploughland, and a strong mixture of French ultramarine and light red for the shadows.

3 Apply the paler washes first, then the darker, allowing some blending. Add some shadows wet-in-wet and finally, when everything is dry, add a few hard-edged shadows.

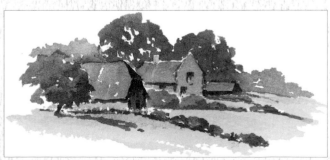

Water

The presence of water in a landscape can lend life and sparkle to the dullest scene or provide a restful passage in an otherwise busy painting. It can link the sky to the land below and may provide welcome horizontals to balance the verticals of trees and buildings in a composition. In common with skies, water demands correct technique and the purest of washes, boldly and quickly applied, to preserve the clarity which is essential to success – any alteration, overpainting or premature drying inevitably leads to loss of freshness and the onset of muddiness. The only approach is careful and thorough planning of strategy followed by its bold and swift execution. Any hesitation or change of plan in midstream spells disaster, and a bold, fresh error is always preferable to a timid and muddy correction.

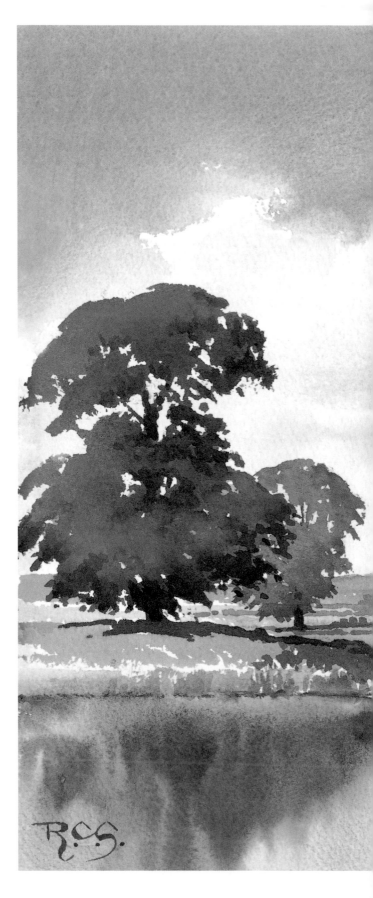

CALM RIVER
The impression of stillness in this painting is mainly created by the expanse of water, in which the soft-edged reflections of the trees show barely a ripple.

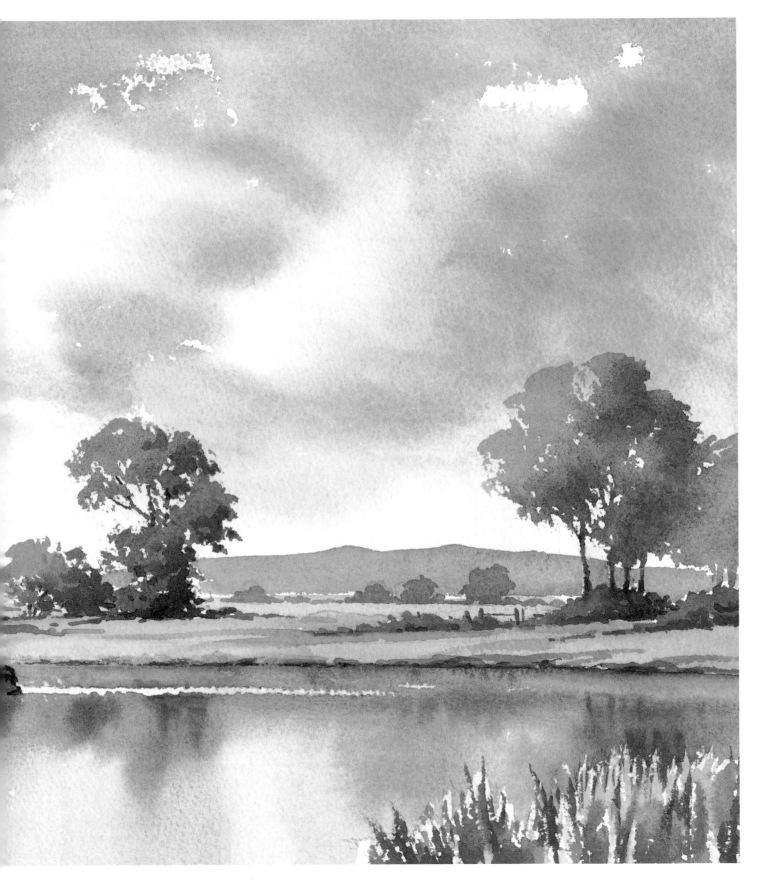

Still water and reflections

If there is no movement at all and no breeze to ruffle the surface of still water, perfect mirror images result. These may look impressive in photographs but are usually less so in paintings. If the scene on land is a complicated one, its inverted image below can compete with it for attention and add to the complication. A softer treatment complements the scene above and provides a calm area where the eye can rest. Try to emphasize the shine and freshness of water by ensuring that there is adequate tonal contrast. Deep-toned riverbanks, for example, make the adjacent water appear to shine by contrast; and, by the same token, areas of dark reflection may be flanked by pale, sunlit reeds, again for the sake of tonal contrast.

Sometimes reflections appear completely soft-edged.

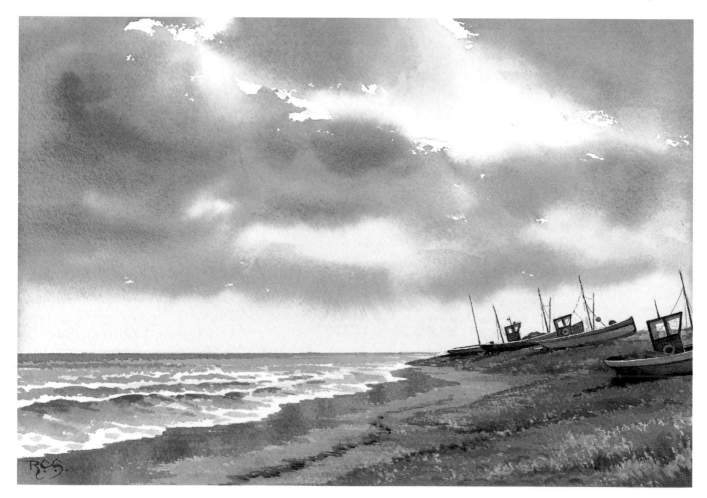

The nature of reflections depends largely upon the strength of the breeze. A gentle zephyr causes gentle ripples, a stronger breeze creates larger ripples or even wavelets, which break up the reflections to some extent and give them a broken or indented outline. The effect of perspective makes the ripples appear to decrease in size as they recede.

In some weather conditions the reflections may be broken up into a myriad of tiny chips. Rather than attempt to labour after such a complex image, view the scene through half-closed eyes so that detail is lost and a soft-edged pattern remains, then paint the reflections using a wet-in-wet technique to ensure a soft merging of colour and tone.

Strong breezes can affect certain parts of a stretch of water and cause the ripples to have steeper sides and reflect the sky above rather than the land beyond. For example, a bend in a river and stretch of lake below a gap between hills are typical areas that may be exposed to stronger breezes. The areas so affected then appear much lighter in tone; and when foreshortened by the angle of vision, they are seen as bands of light across the surface of the water. This effect is well worth incorporating for two reasons: it can help the water surface in your painting to 'lie flat', and it can separate the distant bank from its reflection below to produce useful tonal contrast.

River banks provide tonal contrast with water.

Ripples decrease in size as they recede.

A foreshortened expanse of pale, disturbed water.

BEACHED FISHING BOATS
In this view with a low horizon line, the white horses of the waves accentuate the diagonal angles of the shore and boats, whose masts lead the eye up to the clouds.

There is a general rule that light objects are reflected darker, and dark objects are reflected lighter – in other words, that the tonal contrast is less in reflections – however, always rely upon observation rather than on a rule of thumb. The colours of reflections, too, require careful study and observation: sometimes they are close to those of the objects being reflected, at other times they are strongly affected by the local colour of the water, particularly when they are close and below the angle of vision. In general terms, the steeper the angle of vision, the more the reflections are affected by the colour of the water and take on a greenish hue.

I make a point of completing the painting of the scene on land before tackling the water below, so that I then know exactly what is to be reflected. Careful observation is vital to place reflections in the right place and include just the right amount of the objects being reflected. If there are reeds or fringes of grass in the foreground, these go in last, and if they are pale-toned, leave a jagged edge to the water to accommodate them.

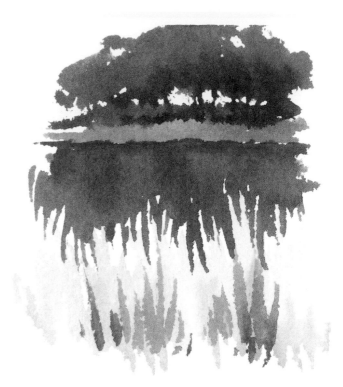

Pale reeds against deep-toned water.

Moving water

Although at first sight fast-flowing water presents a constantly changing and often confused appearance, closer inspection reveals forms and patterns which are constantly disappearing and reappearing.

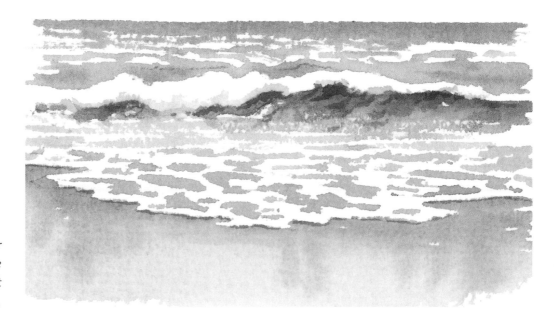

Use masking fluid or candle wax to indicate the pattern of foam left by spent waves.

Light catching the undulations in disturbed water can be preserved on paper by masking fluid, and using it enables you to apply bold and lively washes to the surrounding areas. Foam and spray below cascades can usually be indicated by the white of the paper, and a wet-in-wet technique ensures suitably soft edges.

Waves on the foreshore present a more regular pattern that is constantly being repeated with minor variations. Study their shapes as they become ever steeper and finally break. It is a mistake to include too many waves in a composition, and it is better to make a feature of one and merely indicate a couple more behind it. A broken wash usually takes care of the rest of the waves.

TIP
Rapids and waterfalls make attractive subjects for the watercolourist, but success depends upon the ability to create an impression of movement in the water. The cultivation of a loose and fluid style will help achieve this, while any tightness or obsession with detail will destroy the sought-after feeling of movement.

SEE ALSO:
- Resists, page 24
- Broken washes, page 44
- Wet-in-wet, page 48
- Aerial perspective, page 51

Practice exercise
PAINTING SOFT REFLECTIONS

Soft-edged reflections not only capture the appearance of calm water in certain conditions, but they can also provide a restful area to contrast with the busy scene on land. The wet-in-wet technique required is well worth adding to your artistic repertoire. Why not practise a few soft-edged reflections of your own?

Materials
Sheet of watercolour paper
1-in (2.5-cm) flat brush
No 6 and No 10 round brushes
Paints: raw sienna, burnt sienna, Winsor blue, Payne's grey, French ultramarine

1 Briefly sketch in the positions of the trees, the bank and the water's edge.

2 Paint in the trees and the bank, using various combinations of raw sienna, burnt sienna, Winsor blue and Payne's grey.

3 Apply a pale wash, approximating to the dominant sky colour, over the whole expanse of water, and start dropping in the colours used for the scene above with bold vertical brush-strokes. Finally, add a few dark shadow accents.

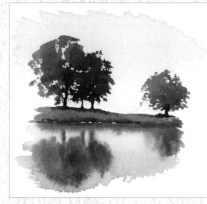

Snow

The onset of winter brings a new dimension to landscape painting: the rich and glowing colours of autumn make way for more muted hues, then snow introduces an entirely new set of tonal values. We are accustomed to the palest tones being in the sky, and sometimes in water reflections, but now the situation is reversed and the lights are all in the fallen snow, with the sky several shades deeper. We have to rethink our scale of tone values and do all we can to emphasize the purity and whiteness of the snow. In practice this means making everything else, including the sky, relatively darker.

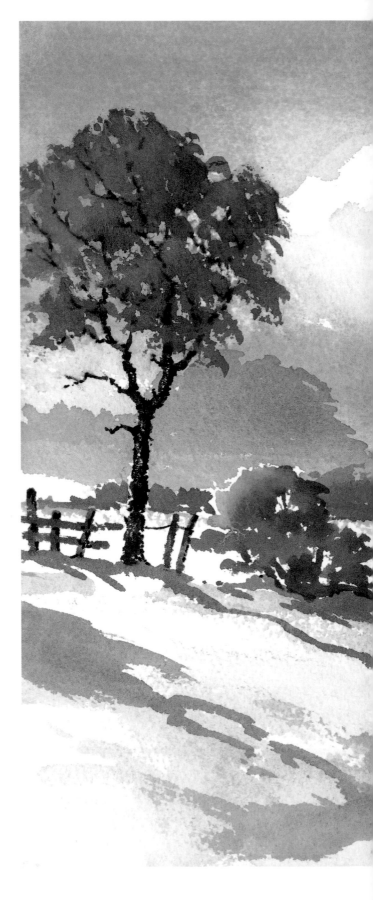

EARLY SNOWFALL

The shadows in the snow take their colour from the sky, which is appreciably darker than the sunlit snow.

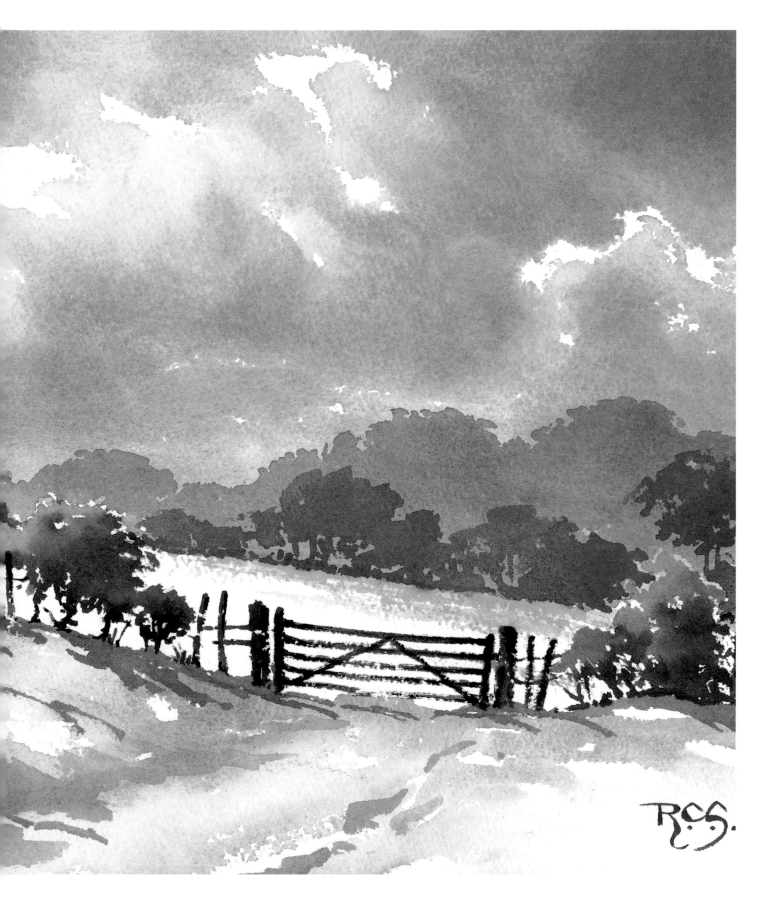

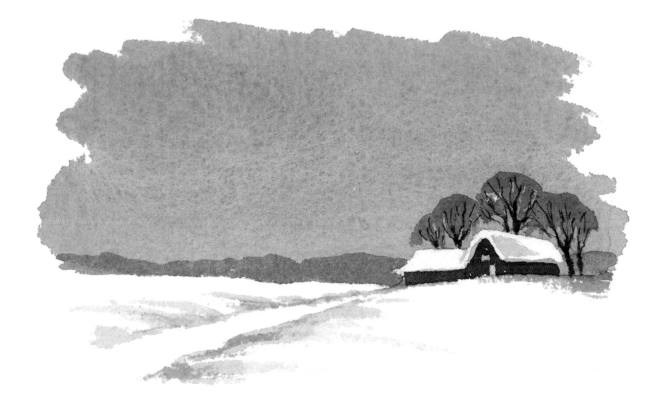

In wintry landscapes, the sky tones are deeper than those of the snowy foreground.

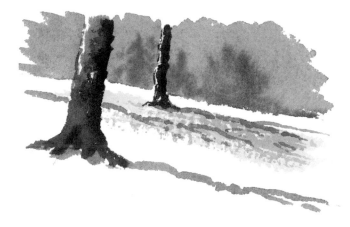

A tree trunk looks close to black against the brilliant whiteness of snow.

Snow colour

In general, the white of watercolour paper serves well for the covering of snow – except where it is in shadow, when the snow takes its reflected colour from the sky. This colour relationship links the sky to the scene on the ground, helping to make the painting unified and therefore to hold it together.

To convey something of the chill of a winter's day, use the cooler colours of the spectrum, such as cobalt, Winsor blue and Payne's grey. As with all such examples, there are exceptions to the 'rule', and you may encounter situations when, however low the temperature, the sky takes on a positively warm shade. On occasions such as these, even the snow shadows must be observed closely, and painted so that they reflect the warmer colours in the sky.

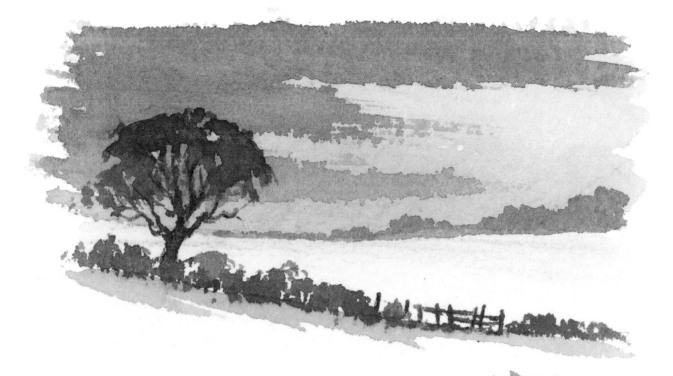

A warm-coloured winter sky.

Filling in the foreground

When the countryside is covered with an unbroken blanket of snow the foreground can lack incident and interest, but you can remedy this situation in all sorts of ways. A few twigs sticking up out of the snow, or ruts appearing in snowy ploughland, are just two examples. It is important to paint these features in the deepest tones to provide the necessary strong tonal contrast with the snow. Do not, however, be tempted to overwork these foreground details, as they can reduce the impact of the snow.

Shadows cast by trees just outside the frame of the painting can also add interest to an empty foreground, and their form can help to describe the smooth, undulating contours of the fallen snow. Tonal contrast decreases with distance, and therefore the tones required for distant trees, ruts and so on are diluted to weaker versions of those in the foreground.

Dark twigs and ploughland ruts stand out against the snow.

The tree shadows add foreground interest by emphasizing the contours of the snowy ground.

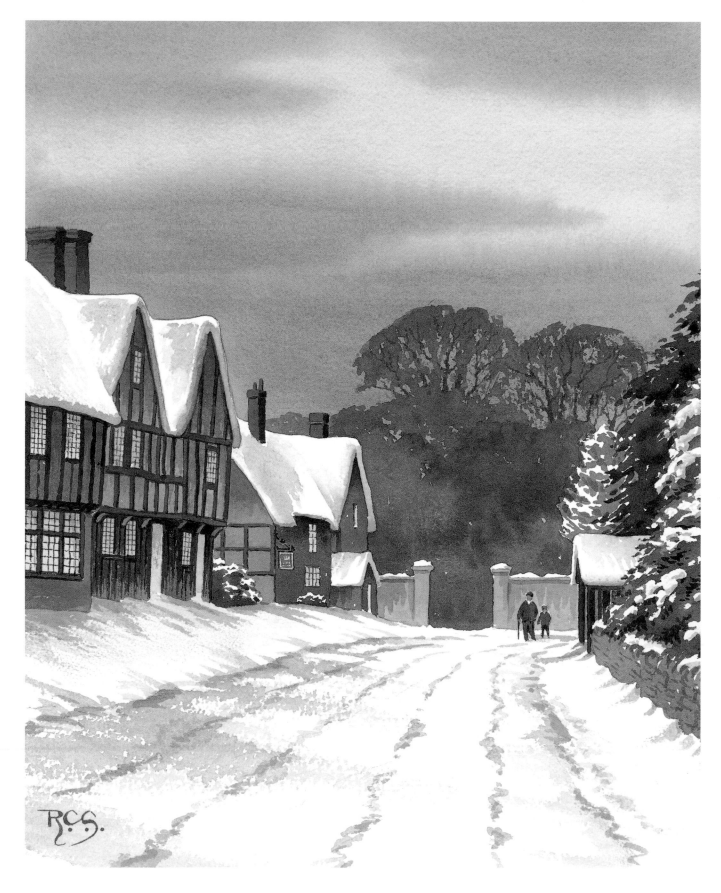

TIP

Although painting in the open air in snowy conditions demands hardiness and also dedication, paint from nature whenever you can, if only to produce the briefest colour and tone study. I remember one occasion when a liquid wash actually froze on my watercolour paper to produce an interesting, if unintended, effect. I now operate from the comfort and warmth of the car but still view my subject at first hand. It is all too easy, when painting away from the source of inspiration, for snow paintings to take on a cozy Christmas-card look instead of reflecting the harsher realities of winter.

SEE ALSO:
- Palette of colours, page 16
- Colour and tone, page 54
- Colour temperature, page 57

VILLAGE UNDER SNOW

Most of this scene is painted in warm colours and tones, which make the small areas of pure white snow stand out all the more.

Practice exercise
FARMLAND IN WINTER

This sketch embodies some of the effects already noted – the sky is several tones deeper than the snow; objects, such as fences, tree trunks and twigs, look almost black against the shining whiteness of the snow; and the shadows in the snow take their colour from the sky. Why not try this little wintry scene for yourself?

Materials
Sheet of watercolour paper
Pencil
1-in (2.5-cm) flat brush
No 8 and No 10 round brushes
Paints: French ultramarine, light red, raw sienna, burnt sienna, Winsor blue

1 Pencil in the positions of the main features.

2 Paint in the sky with plenty of blue-grey cloud shadows using a mix of French ultramarine and light red. Then paint the distant wooded hills with a flat wash of a deeper version of this wash.

3 Paint in the shadows on the snow with the original blue-grey wash, paying particular attention to the surface contours of the snow.

4 Put in the tree, the hedge, the farm gate and the furrows in the ploughland, using various mixes of raw and burnt sienna and Winsor blue.

Bringing it all together

The following pages demonstrate how I develop finished paintings from quick preliminary sketches, using classic watercolour techniques in the process. At the end of each feature I briefly comment upon a particular detail in the painting and list the range of colours used. Because the type and size of brush depends so much upon the scale and style of the individual's painting, I have not given brush details but would simply make the point that it is good practice to use as large a size as you can comfortably manage. Bigger brushes not only hold fuller washes but encourage a bold, free style and discourage fiddling.

You may wish to develop your own paintings from my preliminary sketches or perhaps copy the finished paintings, using the techniques outlined in earlier sections of the book.

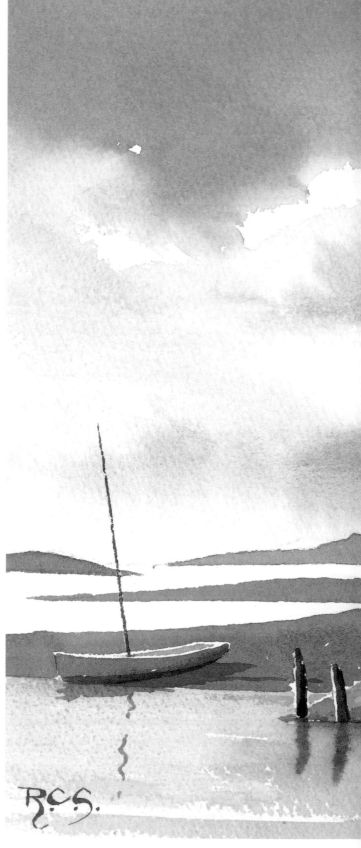

THE WHELK SHEDS
This scene combines many of the features examined in the preceding chapter, including skies, light, water and buildings.

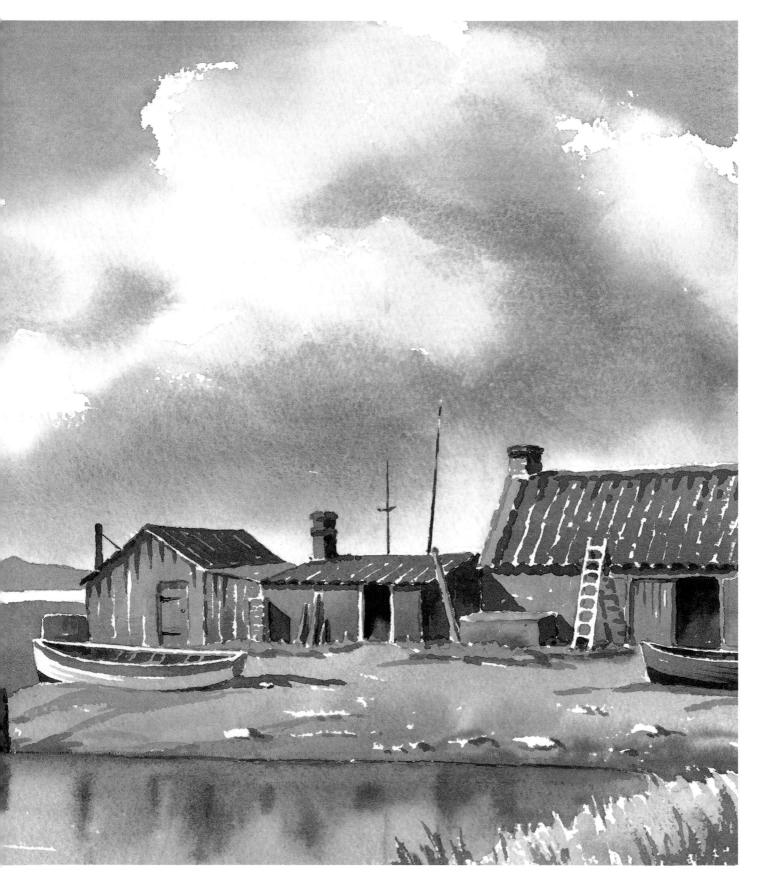

Inner Harbour

This sort of Mediterranean waterfront scene has an irresistible appeal to most artists – my object was to convey an impression of warm sunlight on old colour-washed buildings.

To obtain a harmonious arrangement I placed the church spire towards the right of the painting so that, with the adjacent deep-toned buildings and boats, it would help to balance the main weight of the compositional features on the left. The strong treatment of the shadows suggests hot direct sunlight, and the presence of a few roughly indicated figures brings a little life to an otherwise still scene. The placement of the largest boat breaks up the strong horizontal of the harbour wall, which would otherwise have been too dominant.

The cloudless sky was a variegated wash of French ultramarine and a little alizarin crimson, with the proportion of the latter increasing towards the horizon. The buildings were painted in various combinations of raw and burnt sienna and light red. I then added an impression of weathering and texture with broken vertical strokes of palest light red and French ultramarine.

When painting old buildings, avoid the all-too-common mistake of making their lines too crisp and precise – use the roughness of the paper to help you achieve a more convincing and slightly broken line.

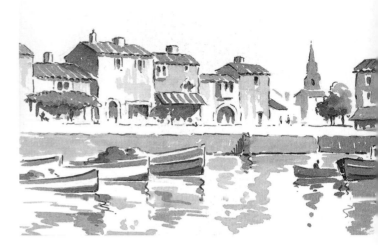

COMPOSITIONAL SKETCH
This preliminary sketch helped me to identify and eliminate such compositional problems as the too-insistent line of the harbour wall.

I used rich but not gaudy colours for the paintwork of the boats, and then suggested the gently rippling surface of the water by painting their reflections with indented edges.

When tackling a scene of this sort, do not worry about accuracy and precision, but rather concentrate on successfully capturing the feeling and atmosphere of the subject. This will not only result in a more confident and more convincing painting, but also takes much less time than aiming for an unachievable likeness!

COLOUR CHECKLIST

French ultramarine

Alizarin crimson

Raw sienna

Burnt sienna

Light red

Cadmium yellow

Winsor blue

SEE ALSO:
- Variegated washes, page 38
- Broken washes, page 44

The broken washes for the roofs and the adjacent indented lines of eaves' shadow suggest the pattern of their pantiled construction.

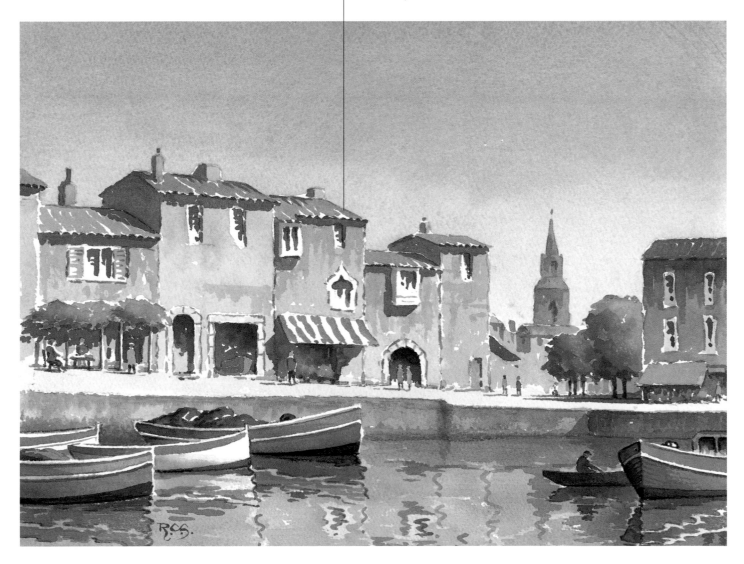

Cumbrian Vista

Here, the level valley floor made a telling contrast with the surrounding rugged hillsides. The hill on the left and the foreground were both in cloud shadow while the valley was sunlit, which provided useful tonal contrast. Although the swiftly moving clouds meant that this shadow pattern would not last, it was there long enough for me to be able to record it.

I simplified the rather complex cloud formation and concentrated instead on two large cumulus clouds. The sunlit areas were palest raw sienna, and I added the cloud shadows with a blend of French ultramarine and light red, applied wet-in-wet. The blue of the sky was a flat wash of French ultramarine with a touch of light red. A couple of quick downward brushstrokes from the base of the left-hand cloud, also wet-in-wet, hinted at a distant rain squall.

The furthest hills were a pale blue-grey – again, French ultramarine with a very little light red – and I dropped in a slightly deeper version of the same wash, wet-in-wet, for the shadows. The hills on the right were mostly in sunlight, and here I used pale blends of raw sienna, Winsor blue and burnt sienna, adding the shadows with French ultramarine plus a little light red, also applied wet-in-wet. The autumnal foliage on the lower hill was mainly burnt sienna with French ultramarine and light red texturing added wet-over-dry.

I used Payne's grey in the deep-toned hill on the left, and this contrasted effectively with the

COMPOSITIONAL SKETCH
I used black chalk for this quick study and concentrated on capturing the strong tonal contrast between the dark hillsides and the sunlit valley.

pale wash of raw sienna plus a touch of Winsor blue which I used for the valley fields. I added the hedgerows and field boundaries in flat washes of Payne's grey, and these helped to emphasize the level nature of the valley floor.

The presence of a farm track in the picture foreground often carries the viewer's eye into the scene beyond, so I indulged in a little artistic licence to include one here; it also served the useful purpose of breaking the strong line of the foreground hedge. I used various blends of raw and burnt sienna and Winsor blue for the hedge, applying the broken washes with the side of the brush to capture its rugged outline. Deep Payne's grey, applied wet-in-wet, provided shadows for the greenish hedge plants, and I applied a strong blend of French ultramarine and light red for the plants tinged with russet.

COLOUR CHECKLIST

Raw sienna

French ultramarine

Light red

Winsor blue

Burnt sienna

Payne's grey

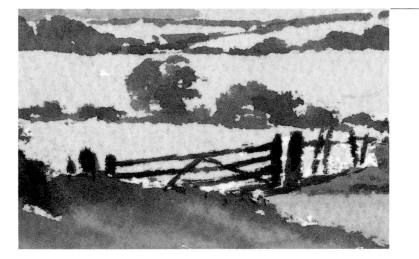

The deep tones of the farm gate make a pleasing contrast with the sunlit fields beyond.

SEE ALSO:

- Flat washes, page 30
- Wet-in-wet, page 48

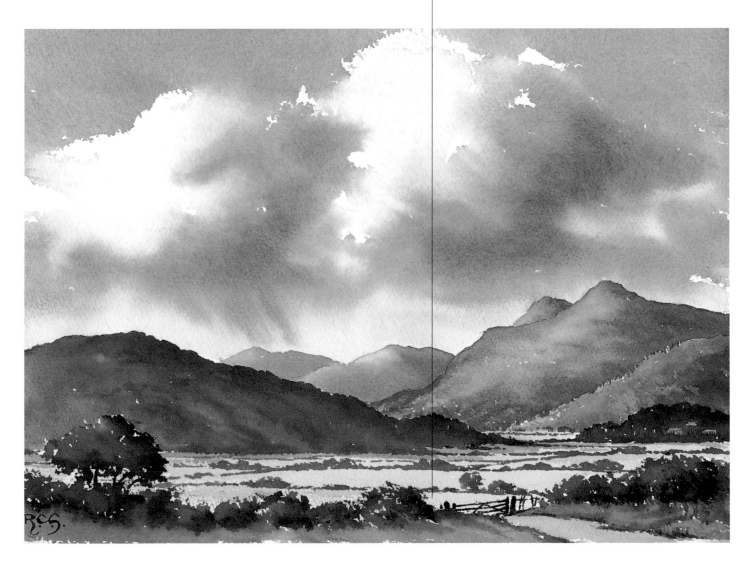

Incoming Tide

It is all too easy for a precise and painstaking approach to result in a static image that has no feeling of movement at all. Wave patterns all differ, so fix a suitable example in your mind's eye and then tackle it as boldly as you can, after preparing the necessary washes in advance.

I prepared three washes for the sky – palest raw sienna for the lower sky, Payne's grey for the upper sky, and a blend of French ultramarine and light red for the cloud shadows. I applied these washes quickly, allowing plenty of blending, but leaving untouched paper for the cloud highlights. I kept the treatment fairly rough, to suggest a blustery day and to tone in with my intended handling of the scene below.

The distant headlands were flat washes of French ultramarine and light red, paling a little towards the right as they receded into the distance. I left the lower edge jagged in places to indicate distant breaking waves, and softened it towards the left with pure water to allow for the upper edge of the wave burst.

For the nearer waves I mixed two washes: a pale one of raw sienna with a little Winsor blue, and a deeper one of Payne's grey with a little raw sienna. I applied the pale one first, leaving streaks of white paper to suggest foam. This pattern is mainly horizontal for the nearer spent wave, but slants upward to indicate the slope of the gathering wave. An extra touch of pale raw sienna suggests the light shining through the rising wave form on the left, while added Payne's grey indicates the shadow under the breaking wave on the right. For the distant

COMPOSITIONAL SKETCH
I frequently combine my preliminary sketch with a tonal study, and find a quick watercolour impression in black monochrome ideal for this purpose.

waves I used French ultramarine and light red, adding wave shadows with a slightly deeper version of the same wash and leaving broken lines of white paper to stand for the white horses on the waves.

I used various flat washes of light red, burnt sienna and a little French ultramarine for the light catching the foreground rocks, adding a mixture of raw sienna and Winsor blue, wet-in-wet, to represent seaweed and marine algae. Strong washes of French ultramarine and light red served for the foreground rock shadows, with a paler wash for the more distant rocks. For the reflections in the strip of wet sand, I added a little Winsor blue, and raw sienna to the colours used for the objects being reflected. The sand was a flat wash of pale raw sienna.

COLOUR CHECKLIST

Raw sienna

Payne's grey

French ultramarine

Light red

Winsor blue

Burnt sienna

SEE ALSO:
- Flat washes, page 30
- Variegated washes, page 38
- Wet-in-wet, page 48

The soft-edged treatment conveys the impression of spray breaking over rocks.

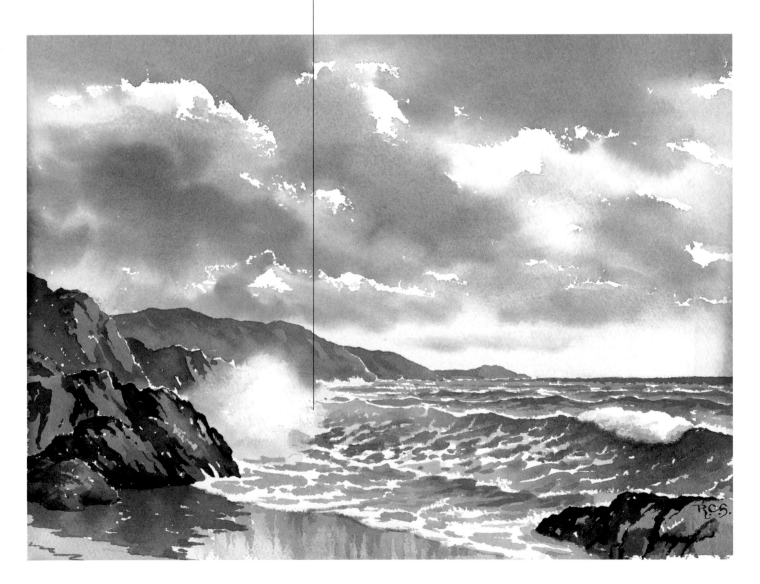

Montmartre

Although this Parisian scene may have been painted many times, in my view we should not be deterred from painting a subject that appeals to us just because it has attracted many others in the past – provided we paint it our own way and do not simply copy someone else's vision and interpretation.

A subject of this sort presents a number of problems, which should be considered carefully before putting brush to paper. Here I was immediately struck by the shining whiteness of the sunlit limestone of the church of Sacré Coeur and felt that the white of the paper, against a deeper-toned sky, would do the trick. The foreground figures were also a vital part of the scene and, as such, needed to be given due prominence, though without adding too much detail or precision. To avoid falling into the trap of overcomplication I decided to simplify their immediate backgrounds and omitted altogether some sections of wall, railings and other details. Because I wanted to concentrate attention on the sunlit buildings, I handled the foreground, which was mostly in shadow, boldly and in deeper tones.

It is always good practice to do full justice to tonal contrasts and, if necessary, to exercise a little artistic licence to produce some if needs be. This usually entails moving the elements of the composition around in order to set lights against darks. In this case the sun was in the optimum position and no such licence was required, although I did emphasize the existing tonal contrasts.

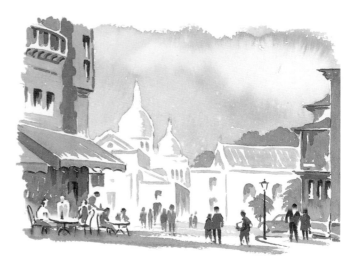

COMPOSITIONAL SKETCH
A complicated subject such as this needs simplifying to avoid the inclusion of excessive detail with consequent overworking. This monochrome watercolour sketch helped me to eliminate inessential elements.

I began with the sky: this was a graded wash of French ultramarine with a touch of light red, and I progressively added a little water as I carried the wash down the paper, to lighten its tone. I used the same colour for the shading on Sacré Coeur, and with rather more light red on the nearer sunlit buildings which were warmer in colour.

The foliage on the trees and the canopy over the street café on the left were flat washes of raw sienna and Winsor blue, while much of the darker foreground – the buildings, figures and roadway – were painted in French ultramarine and light red in varying proportions and strengths.

COLOUR CHECKLIST

 French ultramarine

 Raw sienna

Light red

Winsor blue

SEE ALSO:
- Flat washes, page 30
- Graded washes, page 36

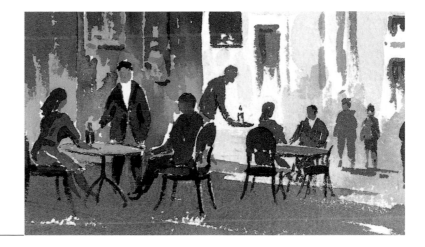

Most of the figures are painted against lighter areas, to prevent them from merging into the background.

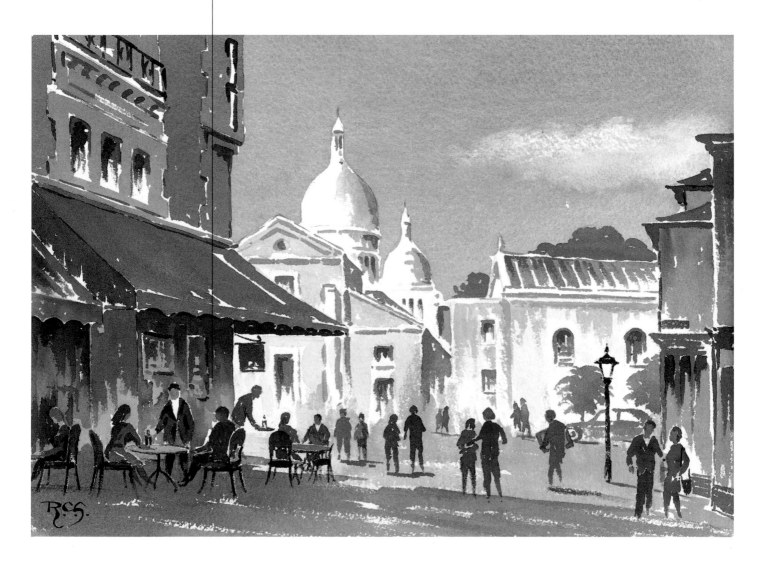

Cornish Harbour

With its wealth of fascinating old fishing villages and harbours, the Cornish coast has long been a Mecca for artists. The margin between land and sea appeals to most painters, particularly where the coastline is rocky, indented and rich in old stone buildings.

In this example, the harbourside buildings and thickly wooded hill form a backdrop, and most of the interest lies in the foreground, where the boats and the harbour wall effectively balance the distant scene. Although much of the sky was clear, there was a mistiness in the atmosphere which softened the light and muted the colours, an effect I was anxious to capture. After quickly sketching in the main features, taking time over the shape of the larger boat, I began with the sky. This was a variegated wash of Winsor blue, with a little Payne's grey, merging into a greenish tinge towards the horizon, created by adding increasing amounts of raw sienna to my pool of colour. In applying this wash I left an irregular area of white paper for the clouds, adding shadow (French ultramarine and light red) wet-in-wet, softening some edges but leaving others hard.

The outline of the sunlit buildings was well defined against the darker trees, but I only hinted at architectural details, with a few deeper accents for shadows and windows. The pale grey of the stonework was made with varying proportions of dilute burnt sienna and French ultramarine, with a few warmer touches of pale light red added. The bank of distant trees was a flat wash of French ultramarine and light red,

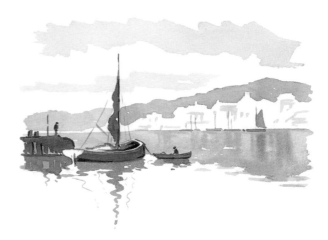

COMPOSITIONAL SKETCH
It is all too easy to lose sight of your initial response to a subject in the process of painting. Making a quick, preliminary sketch helps to fix it in your mind.

with occasional touches of raw sienna dropped in here and there, wet-in-wet.

I used a paler version of the sky colours for the shine on the water surface, applying it as a variegated wash from warm to cool. When this was dry I added the reflections of the distant scene, with paler versions of the colours used for the buildings and trees, and allowed these washes to blend together. Only the margins of the reflections were hard-edged, and their indentations suggested movement in the waters.

Foreground boats, figures, harbour wall and their reflections went in last, in far deeper tones to bring them forward and allow the distance to recede. For this I used strong mixes of French ultramarine, light red, Winsor blue and Payne's grey in varying strengths and proportions.

COLOUR CHECKLIST

 Winsor blue

Payne's grey

Raw sienna

 French ultramarine

Light red

Burnt sienna

SEE ALSO:
- Variegated washes, page 38
- Wet-in-wet, page 48

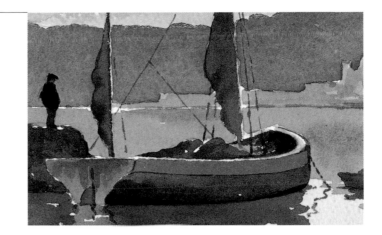

The strong treatment of the boat makes it stand out against the paler distance.

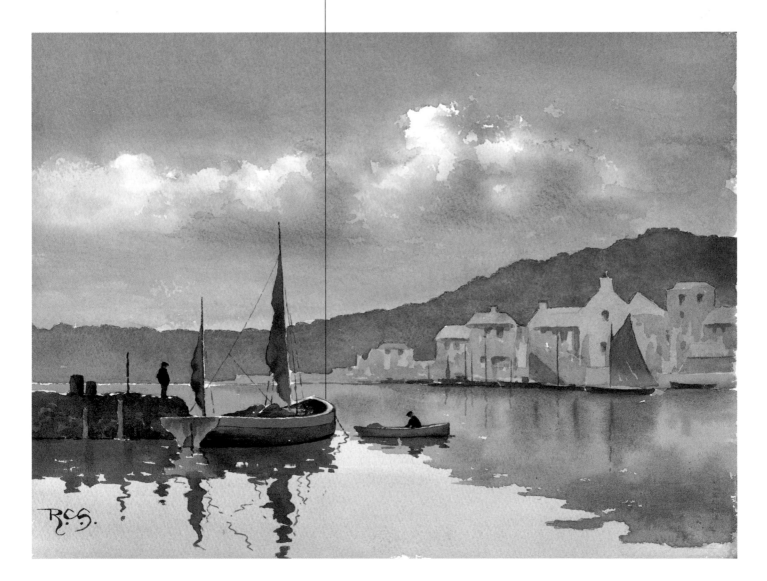

Late Commuters

This quick impression of a damp, foggy, drizzly evening in London is all about atmosphere, with a straggle of office workers hurrying home to their firesides. Here I harked back to the days when smoke in the atmosphere imparted a characteristic warm brownish tinge to the 'London Special' fog – a phenomenon no longer seen in these days of smokeless zones. The scene here is depicted on London Bridge, and there is a suggestion on the left of mist rising from the cold waters of the Thames.

After I had quickly sketched in the main construction lines I applied masking fluid for the office windows, the street lights and their reflections and the light catching the outlines of the figures and their umbrellas. I then applied a variegated wash to the whole sheet of paper, starting with raw sienna and light red for the lightest area above the car. This merged into the next wash, light red with a little French ultramarine, and this in turn blended into the third, rather stronger wash of French ultramarine with a little light red, to which I later added water for the paler area behind the railings. When all this was dry, I used graded washes of French ultramarine and light red for the buildings, making them strong at the top and blending into the underwash below. The pavement was a similar graded wash, strong to the left and then merging into the existing underwash to the right.

When these graded washes were dry, I began to add the details of the paving slabs, kerbs,

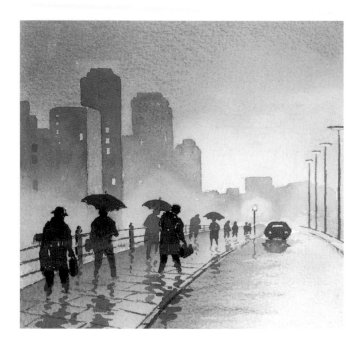

COMPOSITIONAL SKETCH
Misty conditions simplify the distant scene and in this watercolour sketch I concentrate attention on the foreground figures.

light standards, railings and their reflections on the wet pavement and roadway, using French ultramarine and light red washes of varying strengths. The figures, the car and their reflections went in last, in still stronger and varying proportions of the same two colours.

To finish, I removed the masking fluid and added touches of palest raw sienna for the lights and their reflections, and raw sienna plus a little light red for the light catching the figures, taking care that I did not disturb the adjoining deeper washes.

COLOUR CHECKLIST

Raw sienna

Light red

French ultramarine

SEE ALSO:
- Resists, page 24
- Graded washes, page 36
- Variegated washes, page 38

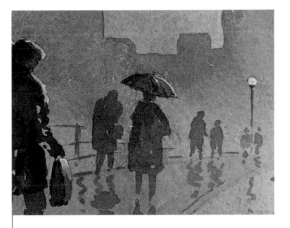

The tones of the figures decrease with distance to suggest recession and emphasize the effect of fog.

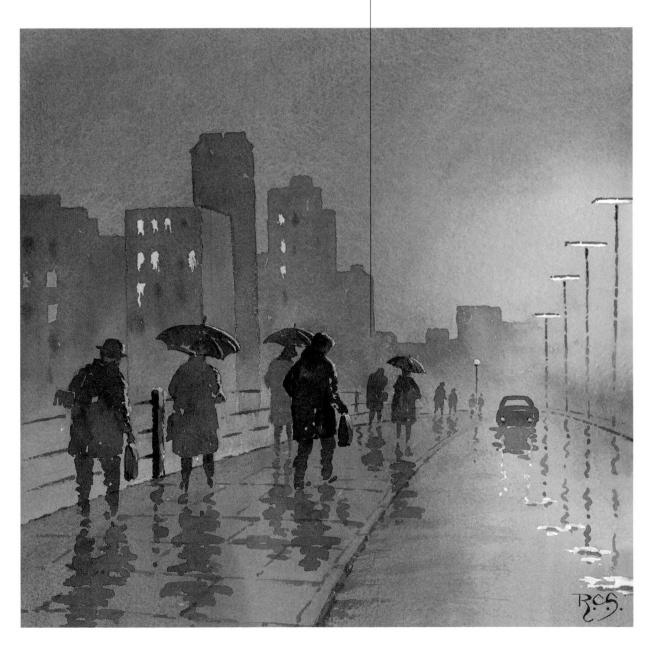

Venetian Vista

In this evening impression made of a corner of Venice's celebrated waterways, the accent is on atmosphere rather than precision. The sunset on this occasion was in fact not a particularly spectacular one, but the gentle light and subtle colours of the evening twilight held a touch of magic, and I did my best to capture it in fluid watercolour washes. Below soft layers of stratus cloud, the pale sky merged into a warm haze above the horizon.

To begin with, I quickly sketched in the principal lines of the simple composition and applied masking fluid to the lit windows and lamps. Next, I prepared three washes: pale raw sienna with a touch of light red for the soft golden light in the upper sky, pale French ultramarine, light red and a little alizarin crimson for the warm haze lower down, and a rather stronger mix of French ultramarine with a little less light red for the soft layers of stratus cloud. I applied the first two as a variegated wash right down to the waterline, and then added the third, wet-in-wet, for the horizontal layers of cloud.

When the sky area had dried, I painted in the line of buildings, including Santa Maria della Salute, using a graded wash of French ultramarine with a little light red, starting on the left and progressively diluting the mixture towards the more distant buildings on the right. When this had dried, I used a slightly stronger version of the same wash to pick out a few architectural details and shadows.

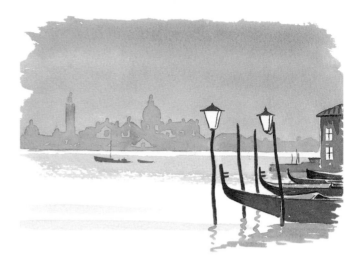

COMPOSITIONAL SKETCH
The strong painting of the foreground objects contrasts with the softer treatment of the distance.

I applied a dilute blend of raw sienna with a touch of light red to the water below and then added to this pale horizontal strokes of French ultramarine and light red, wet-in-wet, to hint at the soft reflections of the buildings and to indicate a couple of foreground ripples.

When everything was completely dry, I removed the masking fluid and lit the lamps and windows with varying mixtures and dilutions of cadmium yellow and cadmium orange. The foreground building, gondolas, mooring poles and their reflections were then painted in boldly, in deeper tones in various combinations of burnt sienna, light red and French ultramarine.

COLOUR CHECKLIST

Raw sienna

Light red

Alizarin crimson

French ultramarine

Burnt sienna

Cadmium yellow

Cadmium orange

SEE ALSO:

- Resists, page 24
- Graded washes, page 36
- Variegated washes, page 38
- Wet-in-wet, page 48

The bold gondolas and mooring poles register strongly against the pale background.

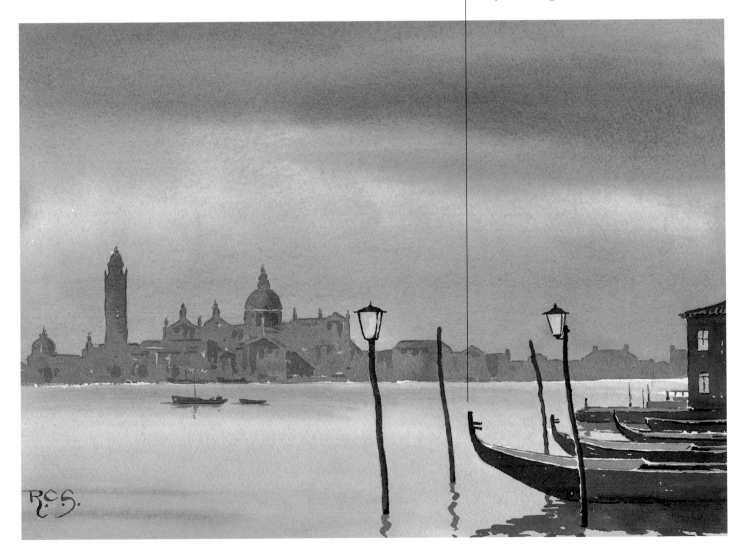

Twilight

A warm light from door and window welcomes the farmer back home from the fields – and challenges the artist to do it justice. However, the minimal area of such windows, relative to their surroundings, often fails to produce the desired impact, and you have to decide what to do to convey the effect you want. The answer lies in tonal contrast and in complementary (opposite) colours.

The complementary colour to the yellow orange in the lit windows is blue, so to obtain the desired effect, you must emphasize the natural blue of twilight, as in this painting. The warm light registers strongly against its deeper, cool surroundings and thus conveys the right message. There are traces of 'local' colour in the foreground grass, lane and ploughland, but the dominant colour is still blue, and this makes the touches of its complementary orange shine out all the more convincingly.

I began by applying an orange made up of cadmium yellow and cadmium orange, and then protected it with masking fluid when it was completely dry. The sky was a variegated wash of French ultramarine and Winsor blue merging gently into raw sienna, with plenty of the blue remaining on the brush. I used flat washes of French ultramarine and Payne's grey for the distant fields, and then carefully added a touch of cadmium yellow for the nearer fields and the foreground grass.

The lines of distant trees and hedgerows

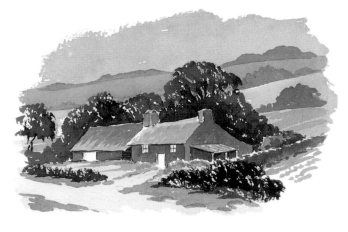

COMPOSITIONAL SKETCH
The colours and tones of late evening need careful handling, and this quick impression underlined the need to emphasize the deep tones of the nearer trees to provide contrast with the lighted windows.

were broken washes of slightly stronger French ultramarine and Payne's grey, and I applied Payne's grey with the side of the brush to achieve broken outlines on the deep-toned nearer trees.

The roof of the cottage was indicated with a variegated wash of pale blue-grey (again a blend of French ultramarine and Payne's grey) merging into green (Payne's grey with a little cadmium yellow) to suggest moss and algae on the lower courses of the slates; these are briefly suggested at the bottom right-hand corner, and then the viewer's imagination does the rest. A touch of burnt sienna added to the ploughland and the roof of the lean-to indicates their local colour.

COLOUR CHECKLIST

Cadmium yellow

Cadmium orange

French ultramarine

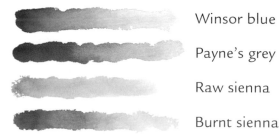

Winsor blue

Payne's grey

Raw sienna

Burnt sienna

SEE ALSO:

- Resists, page 24
- Flat washes, page 30
- Variegated washes, page 38
- Broken washes, page 44

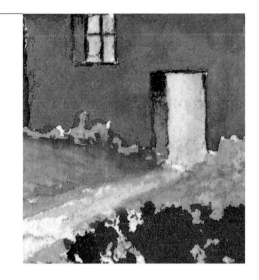

A little cadmium yellow and cadmium orange on the path and grass by the open door suggests reflected light.

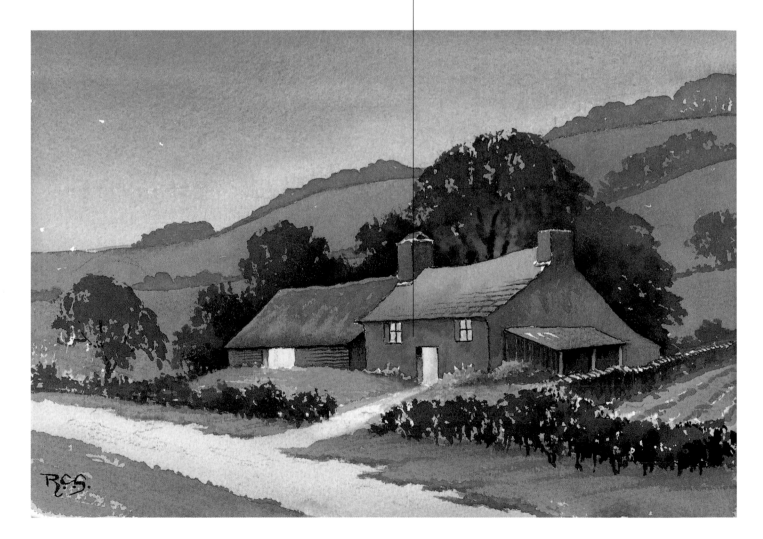

Polperro Harbour

It is not very often that I do not include sky in a composition, but I felt that it would serve no useful purpose in this glimpse of a much-painted Cornish harbour. A portrait format enabled me to concentrate attention on a limited number of harbourside cottages and, at the same time, gave me the space to include a couple of foreground boats.

I quickly sketched in the outlines of all the cottages, and then I spent a little longer over the boats – unless their complex lines are right, the result can look very wrong indeed, as well as thoroughly unseaworthy! Working from light to dark, I began with the pale, colour-washed buildings, using just the white of the paper for one, and very pale, flat washes of raw sienna for the others. For the unpainted stone masonry I used varying blends of raw and burnt umber, adding a little pale texturing here and there with some drybrush work.

I used pale Payne's grey for the slated roofs, with touches of raw sienna added to the lower courses to suggest greenish moss and algae. I then added shadows and some impressions of weathering in varying strengths of French ultramarine and light red washes. The bank of trees behind the cottages was a flat wash of Payne's grey and raw sienna, with slightly deeper touches of Payne's grey dropped in wet-in-wet, to indicate shadow.

I painted the reflections in the smooth water of the little harbour in colours similar to those of the buildings above, and gave such details as windows indented edges to indicate the rippling

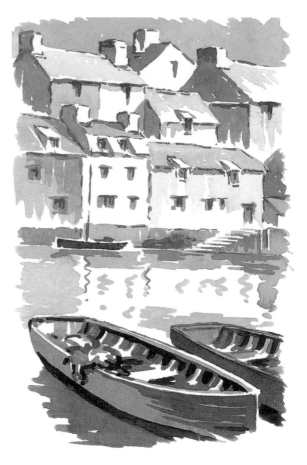

COMPOSITIONAL SKETCH
The foreground boats needed much stronger handling than the more distant harbourside buildings. This quick sketch helped me to judge the relative tones.

surface of the water. But because the colours and tones I had used were those of the objects reflected, the water looked too similar to the buildings above, so I gave it an overall glazing wash of its local colour – raw sienna tinged with Payne's grey. To finish, I painted the foreground boats in deep, strong colours to make them come forward.

COLOUR CHECKLIST

 Raw sienna

Raw umber

Burnt umber

 Payne's grey

French ultramarine

Light red

SEE ALSO:
- Resists, page 24
- Flat washes, page 30
- Variegated washes, page 38
- Broken washes, page 44

Vertical brushstrokes and some drybrush work suggest weathering and texture.

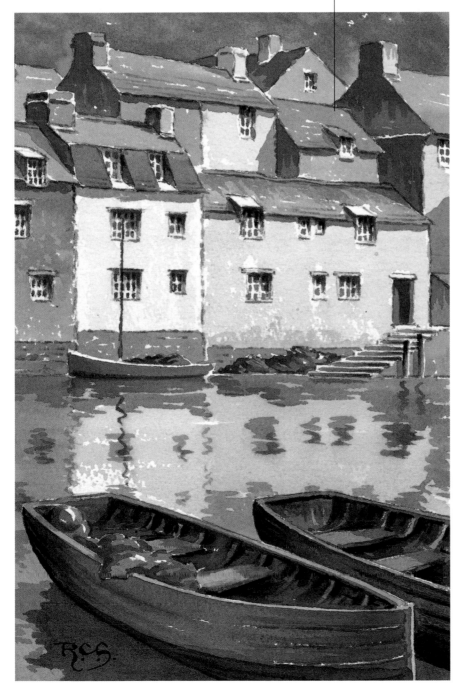

Autumn Copse

I was attracted by the way the evening light caught the warm autumnal foliage and pale trunks of this stand of beech trees, and made this quick impression on the spot. As always, I decided upon the composition with the aid of a brief preliminary sketch and then quickly drew in the main construction lines on my water-colour paper. To preserve the important areas of light on the trunks, I applied masking fluid with an ancient brush well past its prime; when this was completely dry, it gave me the freedom to apply full washes over the top three-quarters of the watercolour paper.

I prepared three washes for the evening sky: raw sienna with a touch of light red for the pale area just about the horizon, light red with a little French ultramarine for the cloud mass, and dilute Payne's grey and French ultramarine for the upper sky. I applied them in quick succession and allowed them to merge into each other wet-in-wet.

While the sky was still wet, I dropped in a blend of burnt sienna and light red for the area of autumnal foliage, and another of French ultramarine and light red for its shadowed side, and then slightly diluted this for the more distant trees. When everything had dried thoroughly, I applied a flat wash of the same warm grey for the line of distant hills and used a stronger blend of this colour to give more form to the trees.

I then removed the masking fluid and applied pale raw sienna and a little Payne's grey to the resulting white areas, quickly adding a

COMPOSITIONAL SKETCH
The evening light on the beech trunks caught my eye and I made the most of it, both in my preliminary sketch and in the watercolour that followed.

strong blend of French ultramarine and light red to the shadowed sides of the tree trunks. I also used various strengths of this warm grey for the branches and twigs.

The grass on the left was raw sienna with a touch of Winsor blue, and this was gradually merged into burnt sienna to depict the beech mast under the nearer trees. The foreground ploughland was a blend of light red and burnt sienna, and I used a slightly stronger version of the same wash wet-over-dry to provide texture. A deeper mixture of French ultramarine and light red served for the tree shadows and for the foreground shadows, cast by a tree just off the picture to the left.

COLOUR CHECKLIST

Raw sienna

Light red

French ultramarine

Payne's grey

Burnt sienna

Winsor blue

SEE ALSO:
- Resists, page 24
- Flat washes, page 30

The pale grey-green of the beech trunks registers strongly against the warm grey background.

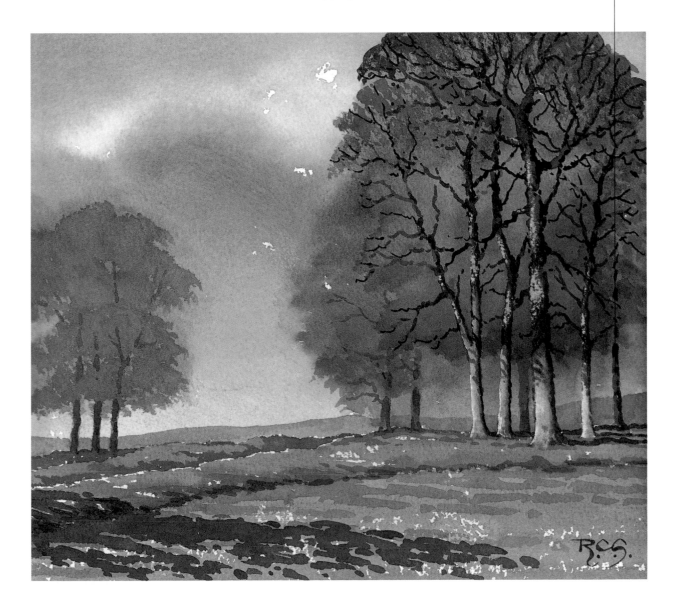

Acknowledgments

I would like to thank my editors, Sarah Hoggett and Freya Dangerfield, and my art editor, Diana Dummett, for their expert help and advice, also my son Paul, M.A. (Royal College of Art), B.Sc.Hons (London University) for his first-rate photography, Susannah Baker and Gillie Simon M.B.E., for their help in skilfully arranging and typing the text, and my wife, Eileen, for her constant encouragement and support.

Index